Reflections on
NELSON MANDELA
ICON OF PEACE

by

Antoinette Haselhorst

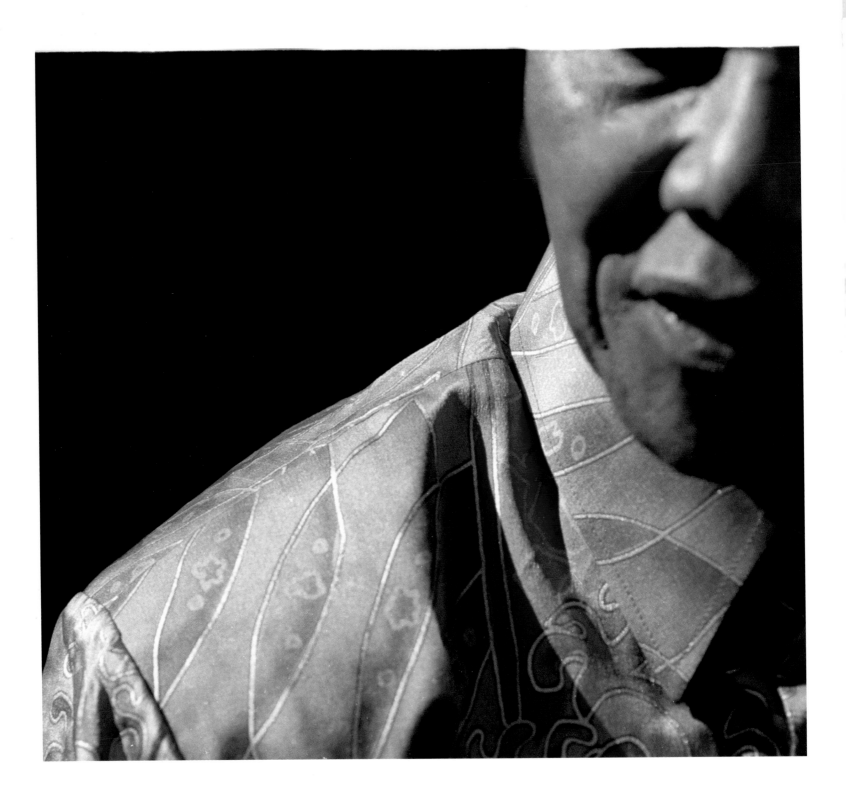

Reflections on
NELSON MANDELA
ICON OF PEACE

by

Antoinette Haselhorst

TITAN BOOKS

BENEFITING THE
Nelson Mandela
CHILDREN'S FUND

CHANGING THE WAY SOCIETY TREATS ITS CHILDREN AND YOUTH

Reflections on Nelson Mandela
ISBN: 9780857685308

Published by
Titan Books
A division of Titan Publishing Group Ltd.
144 Southwark St.
London
SE1 0UP

This edition: January 2012
10 9 8 7 6 5 4 3 2 1

To receive advance information, news, competitions, and exclusive offers online, please sign up for the Titan newsletter on our website: www.titanbooks.com

Did you enjoy this book? We love to hear from our readers. Please e-mail us at: readerfeedback@titanemail.com or write to Reader Feedback at the above address.

A CIP catalogue record for this title is available from the British Library.

Special thanks: Lighthorne Pictures and Naked City Pictures would like to thank Top Tom Doctor for their time and co-operation.

First published in 2010 by Reynolds & Hearn Ltd.

Printed and bound in China

INTRODUCTION

A 16-year-old is introduced to her new classmates by the teacher. It's a nerve-wracking experience for the child who has only recently arrived in Germany. But when her colleagues learn the land from which she has come, their verdict is instant and damning. 'You are a killer and an oppressor of black people,' they accuse. My crime was to have been born a white South African. In the Europe of 1978, this alone was enough to have me branded a murderer.

Even earlier, growing up in a Johannesburg suburb, I'd felt shame for who I'd been born. Of German stock, I'd learnt early on of the Second World War and of Nazi atrocities. Like many of my age and birthright, I struggled with the questions: 'Should I feel guilty for the sins of my compatriots?' and 'Am I innately bad?'

Such anxieties made it very difficult for me to achieve a sense of belonging, and to respect authority and orthodoxies. Once I'd finished my education in Hamburg, I moved to the US to become an Art Director, and then to England where I pursued my career and eventually married.

When Nelson Mandela was released from prison in 1990, I watched events on TV from my home in London and was saddened by how remote I felt from the land of my birth. A year later I learnt, remarkably, that the man who'd go on to become South Africa's first black president had bought the Johannesburg house I'd once lived in as a child.

By now, I was totally disinterested in politics – my career as a fashion photographer and my role as a mother raising a child fully occupied my time and energies. But at an exhibition of my work, I met a magazine editor who suggested I do a book on Mandela. It was 1997 and I was about to embark on a journey through which I'd rediscover South Africa, and its legacy to the world which this man helped create.

Nelson Mandela opened a door to reconciliation. When he was released from his 27-years imprisonment on Robben Island, many were deeply anxious about the future – there was concern that he would be angry and vengeful. Indeed, many felt such a 'payback' would have

been merited. The reality – that Nelson Mandela led the way to forgiveness and reconciliation – is perhaps his greatest achievement.

My correspondents for this book answered one simple question: 'What do you think society, mankind and humanity can learn from Nelson Mandela's values and virtues?' Yes, the reactions of world figures and celebrities were fascinating. But I was just as interested to find out 'the meaning of Mandela' for the man and woman in the street. So their individual, yet often indicative, insights are included here too.

To win these, I took a camera and release form with me whenever I ventured out. Anyone who I felt would make a compelling subject or provide a new perspective, enrich or clarify the issues, was asked for their consent to be photographed and quoted. I wanted these contributors to reflect society's diversity – in this my guide was Nelson Mandela himself, to whom people of every race, colour, age, profession and level of wealth are important.

Forgiveness, patience, concentration, humility, empathy, magnanimity, altruism, sharing, fairness, fraternity, discipline, compassion, equality, respect, dignity, hope, strength, courage, belief, endurance, tolerance, kindness and faith are some of the positive qualities most commonly ascribed to Nelson Mandela. He continues to see the best in people, not out of naivety but through belief.

For me, Nelson Mandela opened a door to reconciliation with my own heritage, too. He showed I no longer needed to feel ashamed. So this book is in part a personal homage to him. It also aims to support Nelson Mandela's Children's Fund and the organisation's work in South Africa.

More than this the book seeks, as best it can, to promote the values for which he stands. To societies strafed by anger, resentment and vengeance, where young people are often unsure of moral boundaries, Nelson Mandela's principles and commitment burn bright. Inspired by this icon of peace, we can all become better and more responsible human beings.

ANTOINETTE HASELHORST

London, April 2010

Brief biography of:
NELSON MANDELA

Nelson Mandela was born on 18 July 1918 and, after a life long struggle against apartheid, became President of the newly democratic South Africa in April 1994.

As a young man Mandela qualified as a lawyer, setting up a practice in Johannesburg with his friend Walter Sisulu. It was the injustices he dealt with on a daily basis that began to influence him. In 1943 Mandela joined the African National Congress (ANC), which appealed to the South African government for African rights and political changes.

Following the introduction of apartheid laws in 1948 Mandela was banned, arrested and detained numerous times. The ANC was declared an illegal organisation in 1960. As a last resort, after the failure of peaceful resistance to challenge government oppression, Mandela founded Umkhonto we Sizwe (MK), or 'Spear of the Nation', which was prepared to use limited sabotage against the South African government with the aim of achieving policy change. Mandela was eventually arrested and tried for treason. His final speech at the trial summed up his vision for the future of South Africa:

'I have cherished the ideal of a democratic and free society in which all persons live together in harmony and with equal opportunities. It is an ideal which I hope to live for and to achieve. But if needs be, it is an ideal for which I am prepared to die.'

On 12 June 1964 Nelson Mandela was sentenced to life imprisonment.

During his 27 years in confinement he remained an inspirational role model for many of his fellow inmates. In the outside world he became an icon, who was globally synonymous with the struggle for human rights and resistance to oppression.

When Nelson Mandela was released from prison on 11 February 1990, many people both in South Africa and beyond were deeply anxious about the future – there was concern that he would be angry and vengeful.

His impact was so powerful because he understood those fears and was genuine in his calls for forgiveness and reconciliation. His goal was to unite South Africa into a multicultural democratic country after so many years of oppression and convinced the world to support him in his endeavors.

Mandela began negotiations and led a peaceful transition to a multi-racial democracy in South Africa. He led by example, showing forgiveness, understanding and a belief in the goodness of others.

Since the end of apartheid many, including former opponents, have praised Mandela. He has received more than one hundred awards over four decades, most notably the Nobel Peace Prize in 1993.

That he achieved his goal is a tribute to the remarkable human being that he is, and many books have been written about this extraordinary man and his wisdom. He became a world hero and everyone wanted to meet him and be seen with him.

Nelson Mandela has touched people's lives and has become the embodiment of much that is good in the world. He has not become merely a figure of historical importance and interest. He still appears regularly on the world stage. His role as an inspirational icon is assured.

What do you think SOCIETY, MANKIND and HUMANITY can learn from Nelson Mandela's values and virtues?

es ?
rtues ?
d virtues ?
and virtues ?
ues and virtues ?
values and virtues ?
a 's values and virtues ?
dela 's values and virtues ?
andela 's values and virtues ?
Mandela 's values and virtues ?
son Mandela 's values and virtues ?
Nelson Mandela 's values and virtues ?
m Nelson Mandela 's values and virtues ?
from Nelson Mandela 's values and virtues ?
arn from Nelson Mandela 's values and virtues ?
learn from Nelson Mandela 's values and virtues ?
can learn from Nelson Mandela 's values and virtues ?
TY can learn from Nelson Mandela 's values and virtues ?
NITY can learn from Nelson Mandela 's values and virtues ?
MANITY can learn from Nelson Mandela 's values and virtues ?
HUMANITY can learn from Nelson Mandela 's values and virtues ?
nd HUMANITY can learn from Nelson Mandela 's values and virtues ?
D and HUMANITY can learn from Nelson Mandela 's values and virtues ?

What do you think SOCIETY, MANKIND and HUMANITY can learn from Nelson Mandela 's values and virtues ?

and HUMANITY can learn from Nelson Mandela 's values and virtues ?
d HUMANITY can learn from Nelson Mandela 's values and virtues ?
UMANITY can learn from Nelson Mandela 's values and virtues ?
ANITY can learn from Nelson Mandela 's values and virtues ?
ITY can learn from Nelson Mandela 's values and virtues ?
Y can learn from Nelson Mandela 's values and virtues ?
n learn from Nelson Mandela 's values and virtues ?
learn from Nelson Mandela 's values and virtues ?
n from Nelson Mandela 's values and virtues ?
rom Nelson Mandela 's values and virtues ?
Nelson Mandela 's values and virtues ?
elson Mandela 's values and virtues ?
on Mandela 's values and virtues ?
Mandela 's values and virtues ?
ndela 's values and virtues ?
ela 's values and virtues ?
's values and virtues ?
alues and virtues ?
es and virtues ?
nd virtues ?
virtues ?
tues ?
s ?

The MAN who SHOOK the WORLD

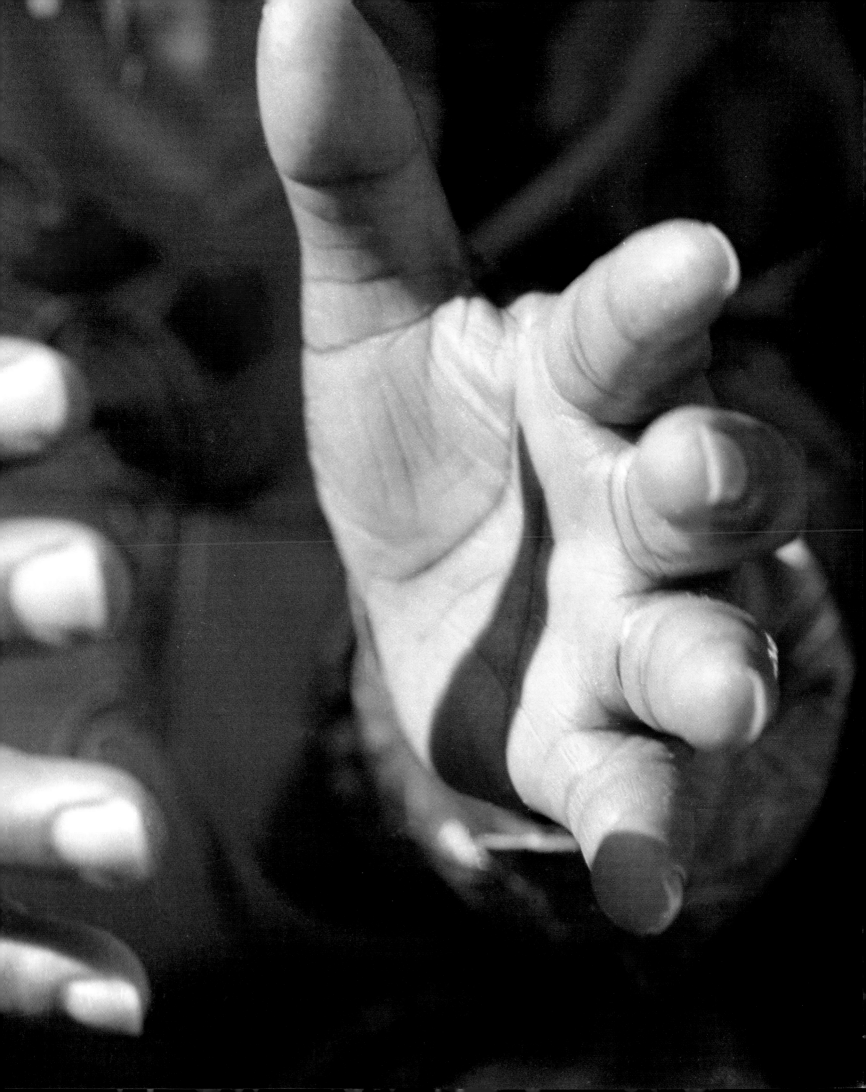

ACTOR
KEVIN SPACEY

It is difficult to ask to write about the impact that Nelson Mandela has had on our world. Obviously, **his message of patience and hope is admired and embraced by people all over the globe.** *But the spirit of ideals will perhaps live most strongly in the* **hearts and minds of all South Africans, whose freedoms and liberties were given such a new birth as a result of his personal suffering and leadership – both while imprisoned and upon his own walk towards freedom.**

I had the privilege of having met Mr Mandela both in New York and in South Africa and **his presence was one of the more impressive I have ever experienced.** *I think I most enjoyed watching how kids responded to him and his words, with enthusiasm and a light in their young eyes. He has been and continues to be an inspirational figure who provides hope and guidance to people and nations across the globe. His* **leadership** *will continue* **to inspire**, *from the depth of his commitment and breadth of his reach,* **for generations to come.**

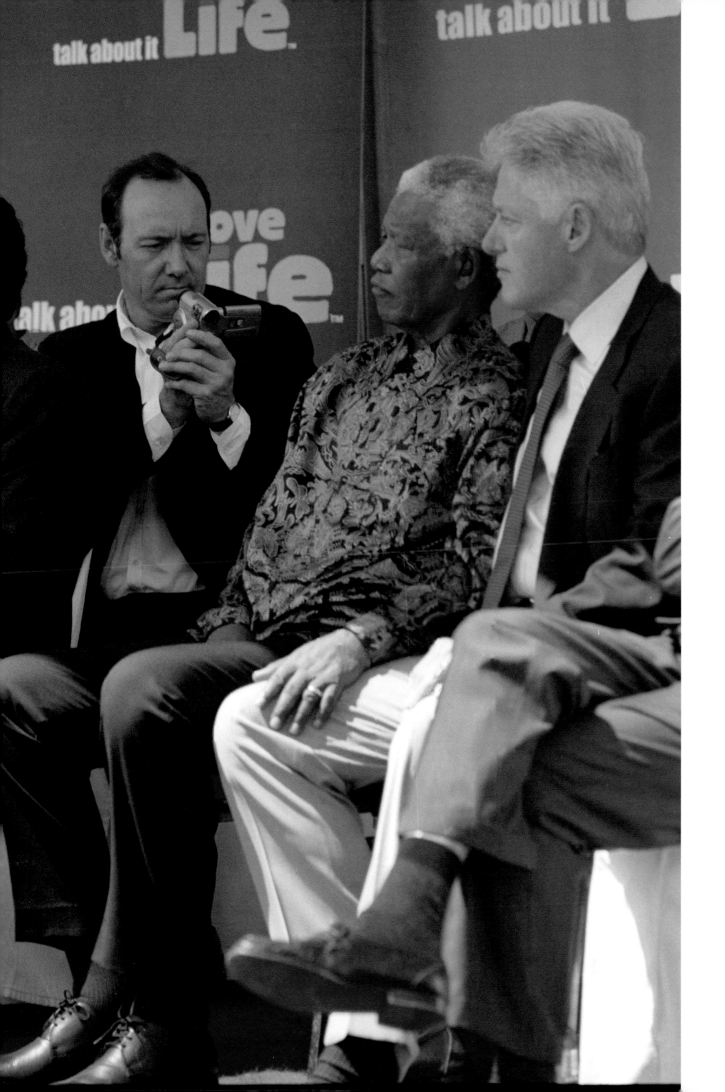

I remember lighting the Special Olympics Torch with President Mandela at Robben Island in 2001. There we were, in a cell where he was oppressed for years, and **all that he talked about was tolerance, forgiveness, and hope.** I walked away thinking that this was the kind of man *all of us aspire to be.*

For me, the action always speaks louder than the words, and this is someone who was released from prison and immediately made **peace** with the people who kept him there, even taking the wife of the warden to lunch. President Mandela sent **a simple message:** Even though he and his fellow prisoners had been put through a terrible ordeal, their captors would be treated with **fairness** and respect. **He had the vision and the compassion to bring his country together.**

President Mandela didn't just **make the world a better place;** he showed the rest of us exactly what we're capable of so that we can attempt to follow in his footsteps and improve our corners of the globe.

So, what can we learn from President Mandela's values and virtues? The short answer is **everything.**"

FORMER CALIFORNIA GOVERNOR
ARNOLD SCHWARZENEGGER

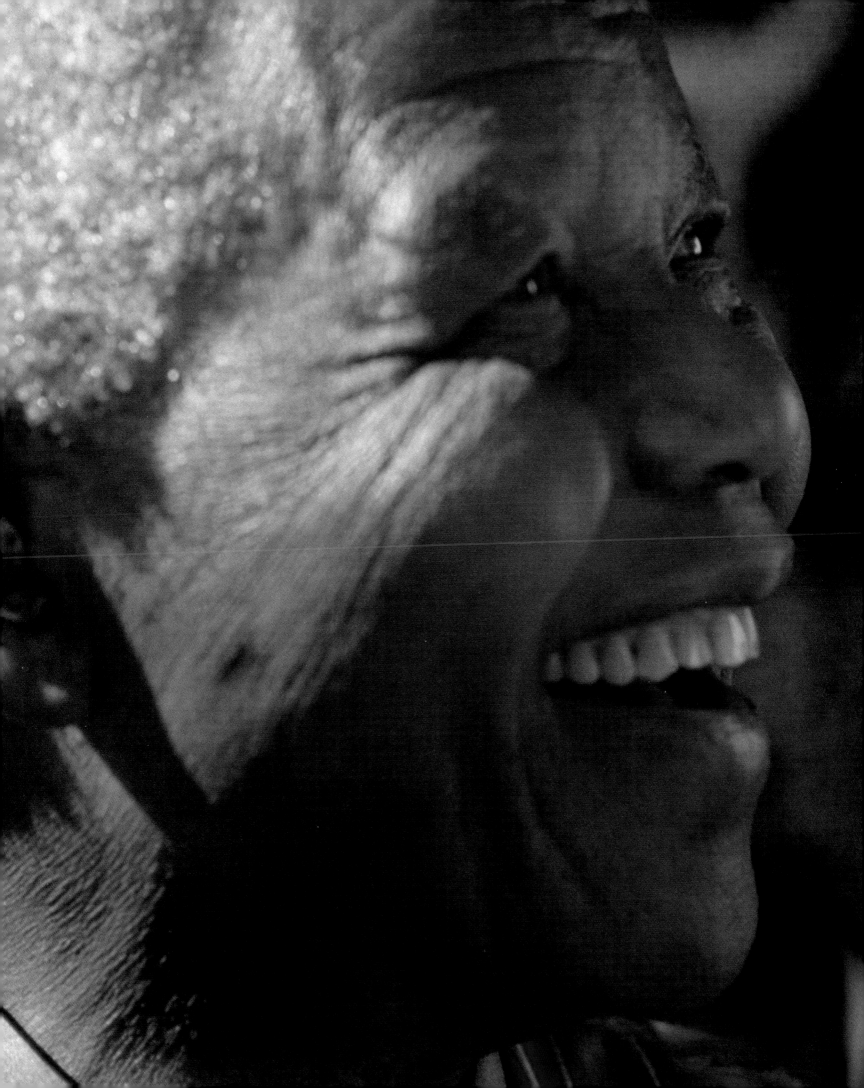

PROSPECT MANAGER
FUN TONG

Being one of the modern icons of peace and humanity, I find Nelson to be a very inspiring leader of our time. *His experience and achievements has shown that he is a* **hero of the struggle** *against government and social oppression.* **Despite a lifetime of persecution, and 27 years of imprisonment, Mandela still fights on for freedom and human /racial equality for the unfortunates who suffer from these crimes.**

Personally I find Mandela's determination **and his hunger to set wrong things right** *as attributes that I find most inspiring.* **This is displayed in his work for the AIDS awareness** *campaign and when he served as* **president of South Africa. His ability to** resolve political issues without using violence as a solution **is what makes him stand out against other political leaders of our time.**

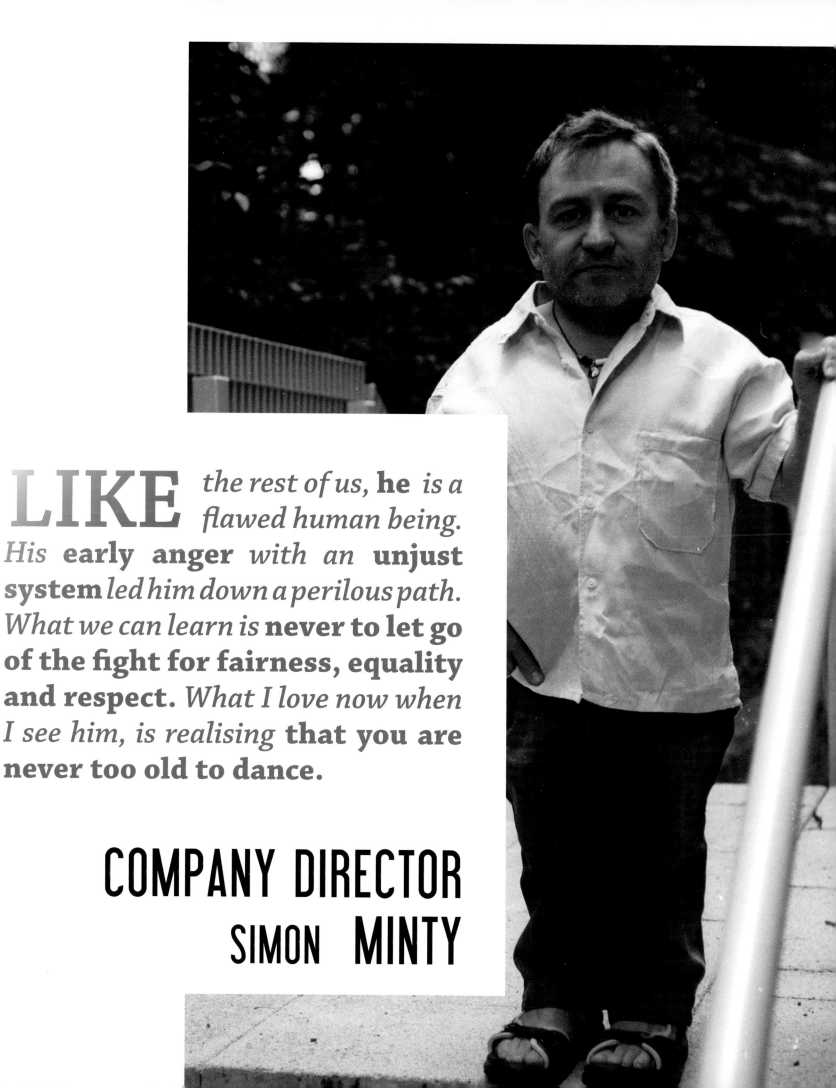

LIKE *the rest of us,* **he** *is a flawed human being.* His **early anger** *with an* **unjust system** *led him down a perilous path.* *What we can learn is* **never to let go of the fight for fairness, equality and respect.** *What I love now when I see him, is realising* **that you are never too old to dance.**

COMPANY DIRECTOR
SIMON MINTY

Values *in life are very important.*

NEVER TAKE LIFE FOR GRANTED.

Justices; NEVER GIVE UP HOPE IN WHAT YOU BELIEVE.

ALWAYS HAVE FAITH *in what you believe and...*

DON'T TAKE LIFE TOO SERIOUSLY.

DIRECTOR
PETER CAMPELL

Nelson Mandela taught me *that* *only through* **forgiveness can one** achieve real freedom...

TAP DANCER
ELLIE GLIKSTEN

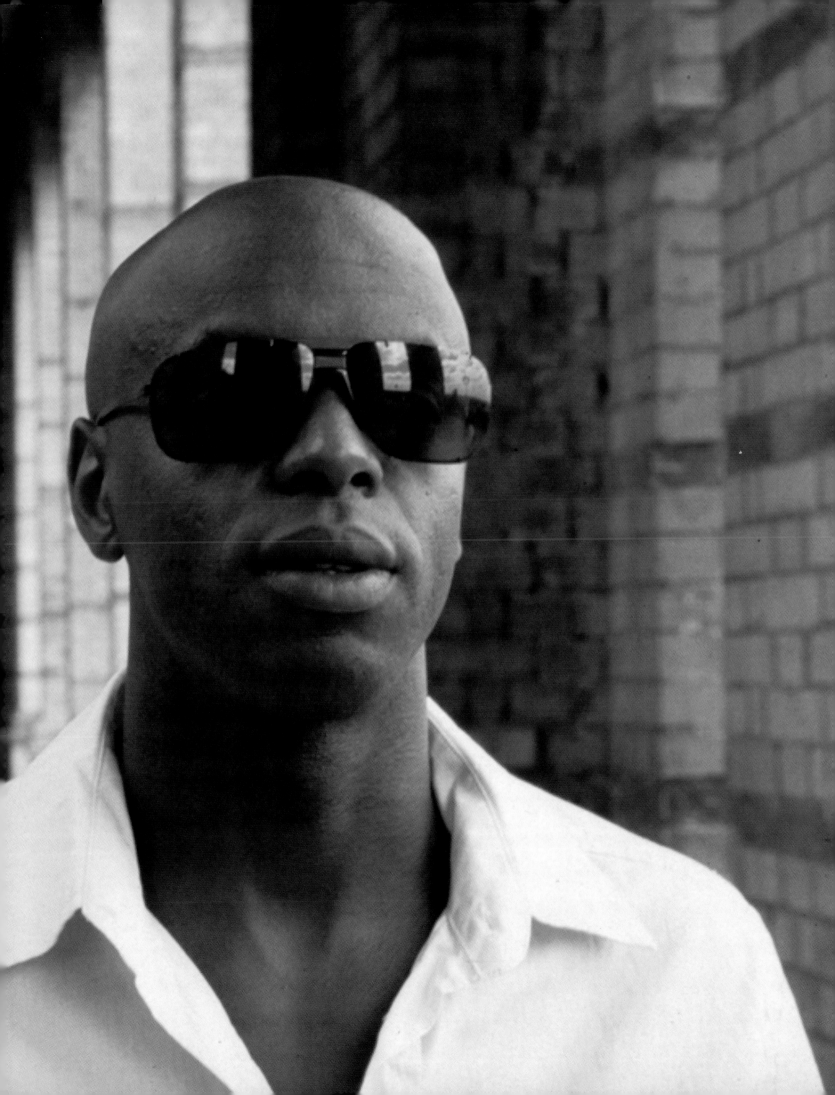

He *shows us* **dignity** *in the face of* **adversity, pride in your heritage** *and* **human rights,** *a combination of* **Malcolm** *and* **Martin.**

DJ/BROADCASTER
TREVOR NELSON

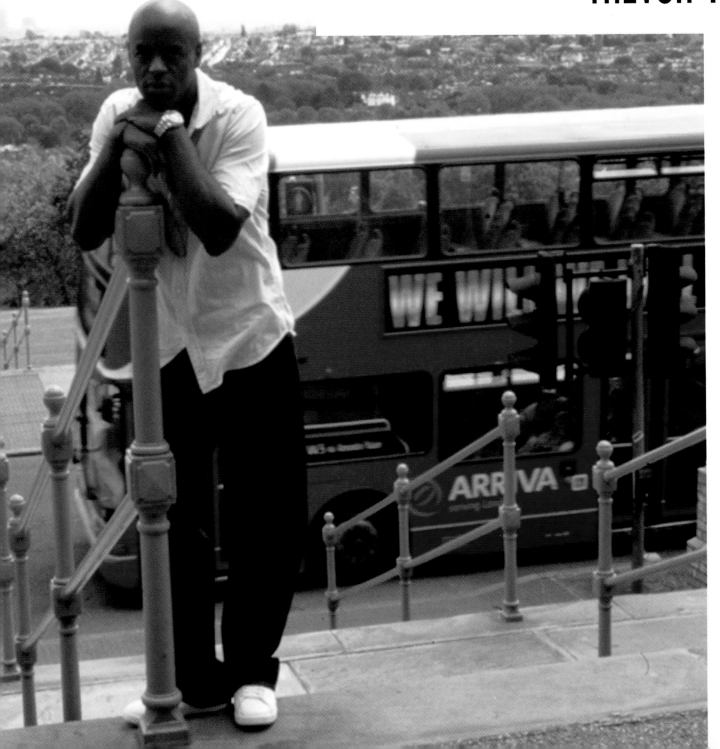

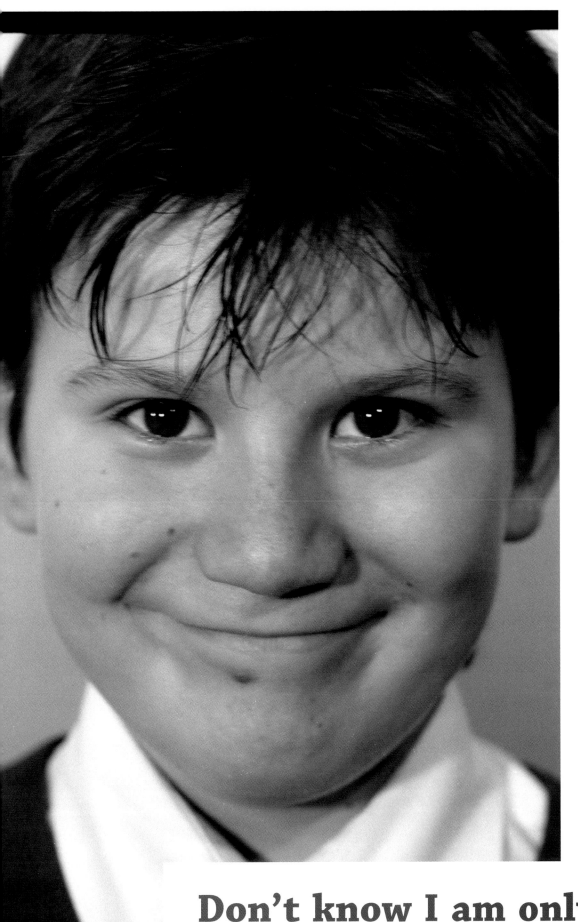

8 YEARS
MAX BEDFORD

Don't know I am only 8 years old.
(My mum said he is a wonderful man)

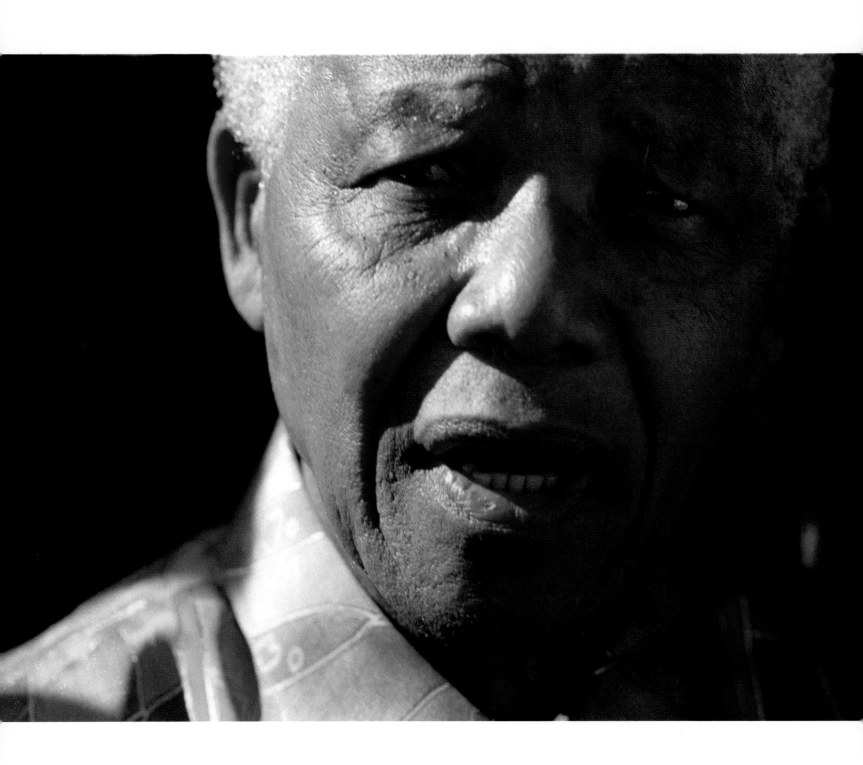

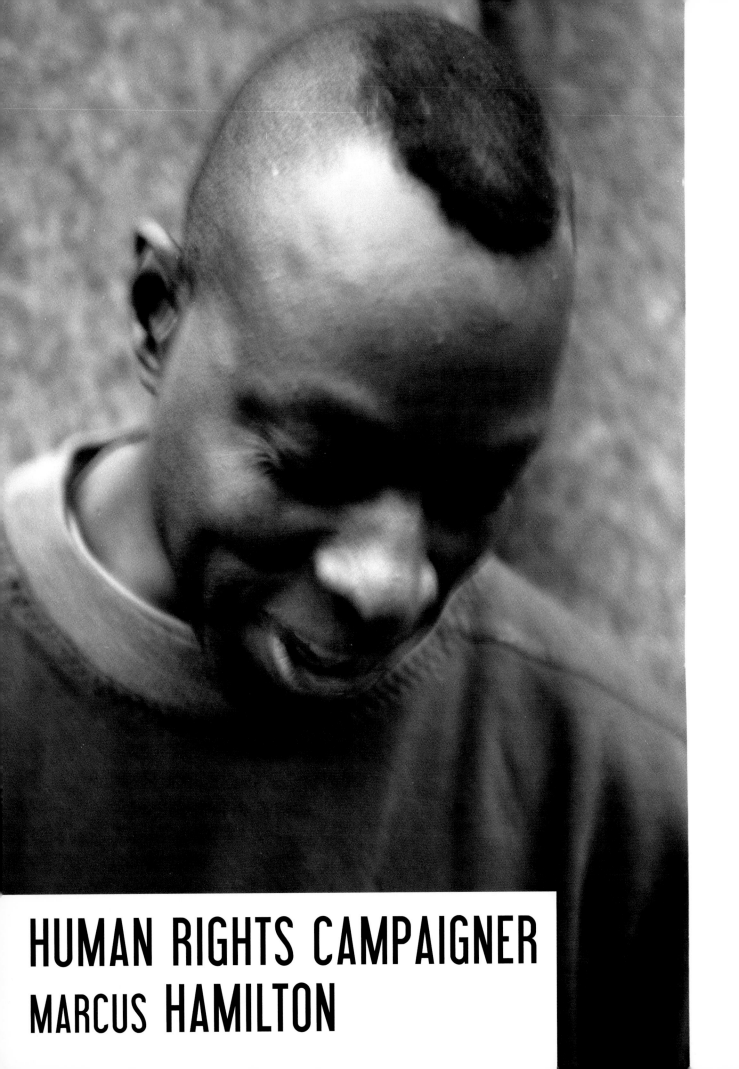

HUMAN RIGHTS CAMPAIGNER
MARCUS HAMILTON

I firmly believe that changing the world in a beneficial capacity is an inspiration shared by many an individual, certainly at some point in their lives. I hold the view that all too few of these individuals come from a relatively humble background but yet through their experiences they seem to be able to rise above the insurmountable obstacles that appear before them. I can think of **no better example of this** than **Nelson Mandela. Labelled a criminal, outlaw, terrorist amongst many other derogatory titles, he strived and fought against true tyranny,** I believe, due to his strength of convictions to affect change. What Mr Mandela accomplished **is not only remarkable, but furthermore,** I would say **the manner** in which **he effected** his **accomplishments** is just as **remarkable.** It is **a tribute** to this **remarkable man** that even those who hate him and have vilified him, have had no choice but **to respect him. To have seen the entire world applaud him has been an experience that one can only treasure.**

I was at school with **Madiba's** daughters Zindzi and Zena in Swaziland in the early seventies. Back then it seemed impossible that he would ever be released, let alone become president.

His message of Ubuntu – to forgive but **not forget** – is a measure of this **unique man's compassion** and **kindness**. **It is his gift to the world for generations to come.**

An example of how **to conduct yourself against all odds**.

ACTOR
RICHARD E GRANT

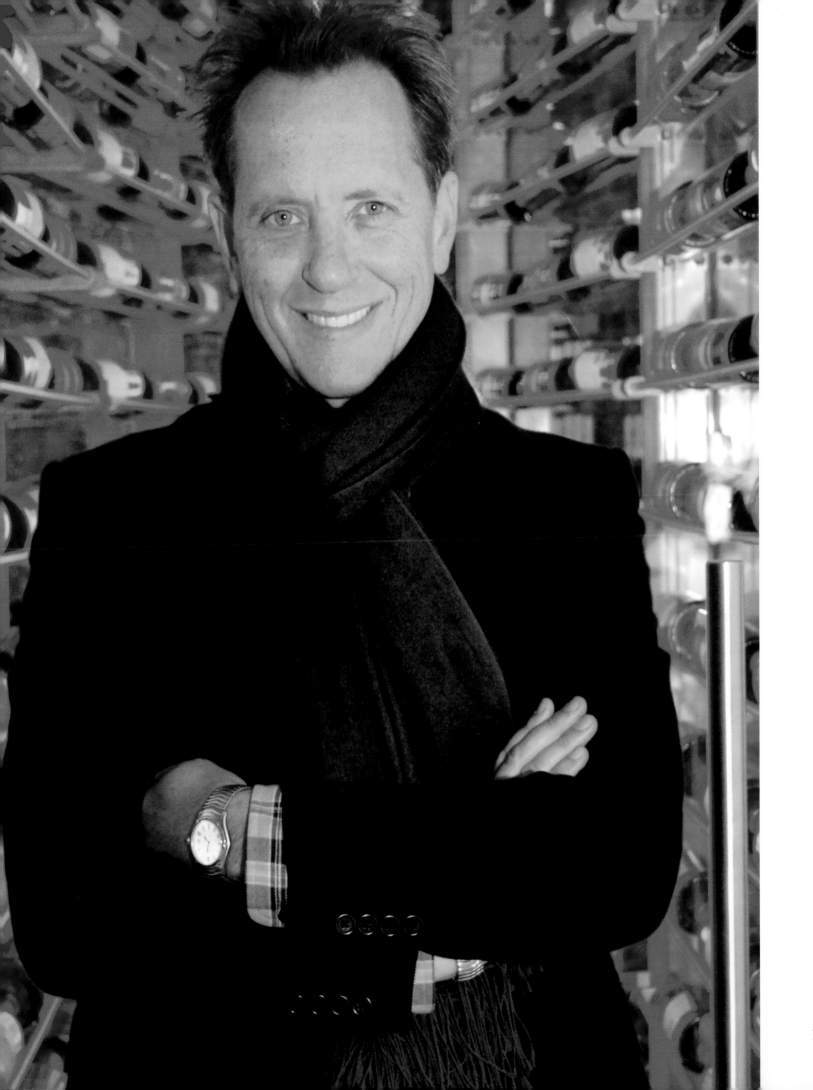

My awareness of Nelson Mandela was gained as a youngster from TV reports and the songs of pop stars. I was not really aware of the struggle of the black community in South Africa as I came from a northern white working class background. As I matured I became more conscious of the oppression and apartheid in South Africa.

When in the eighties the world rocked to the sound of 'Free Nelson Mandela' I wondered just how many were there because of the struggle for his release and black freedom or just the music of the stars. Throughout all that had befallen Mandela he remained strong with a God-given strength and humility that could only be exhibited by a man with a true virtuous conviction.

Throughout his many decades in prison and the tortuous conditions he endured he was not interested in securing his own release but the release of his African brothers and sisters. This was achieved when he was freed by De Klerk, and was then elected President and took his rightful place as the guiding benevolent father figure he is. When released from Robben Island he shook the hands of his jailers and walked free.

We can learn from the inner strength of this patient man; he survived because of his single-minded conviction. We who are not as strong - we, the weak ones, we can survive too.

I pray to God as I am sure Nelson Mandela must have prayed that like him we will all one day be free.

ARTIST
STEVE BAYLOCK

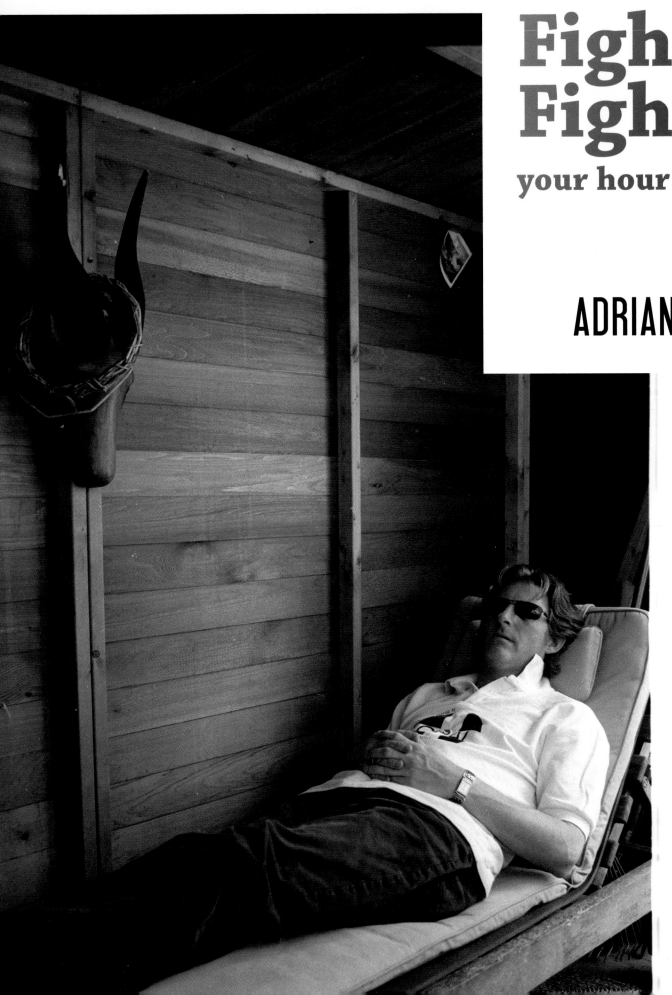

He is **living proof** of the call,

Fight on, Fight on,
your hour will come!

ACTOR
ADRIAN DUNBAR

JAZZ/CLASSICAL MUSICIAN JUDE BAPTISTE

He *was* **fighting for people's rights, fighting for peace of the world, fighting against the oppressors.** *He was trying to show the younger ones that it is possible to be wounded and* **to stand up** *and* **try again**, *because* **a slip is not a fall**. *Mandela didn't only try to free his people* **he was trying to free the world of peoples.**

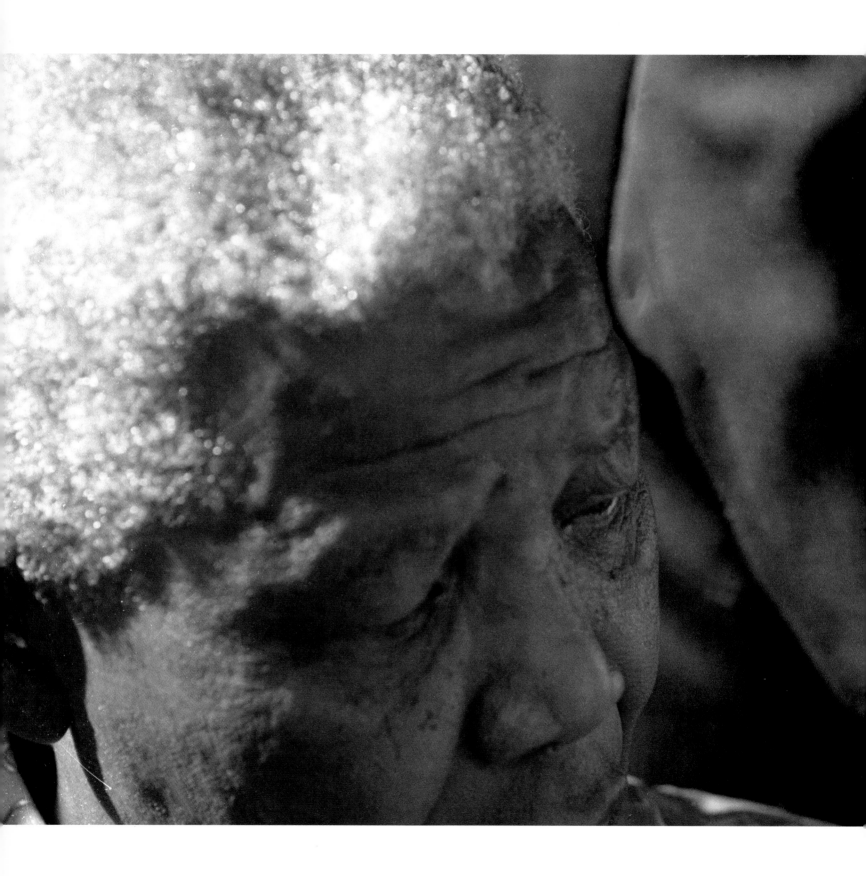

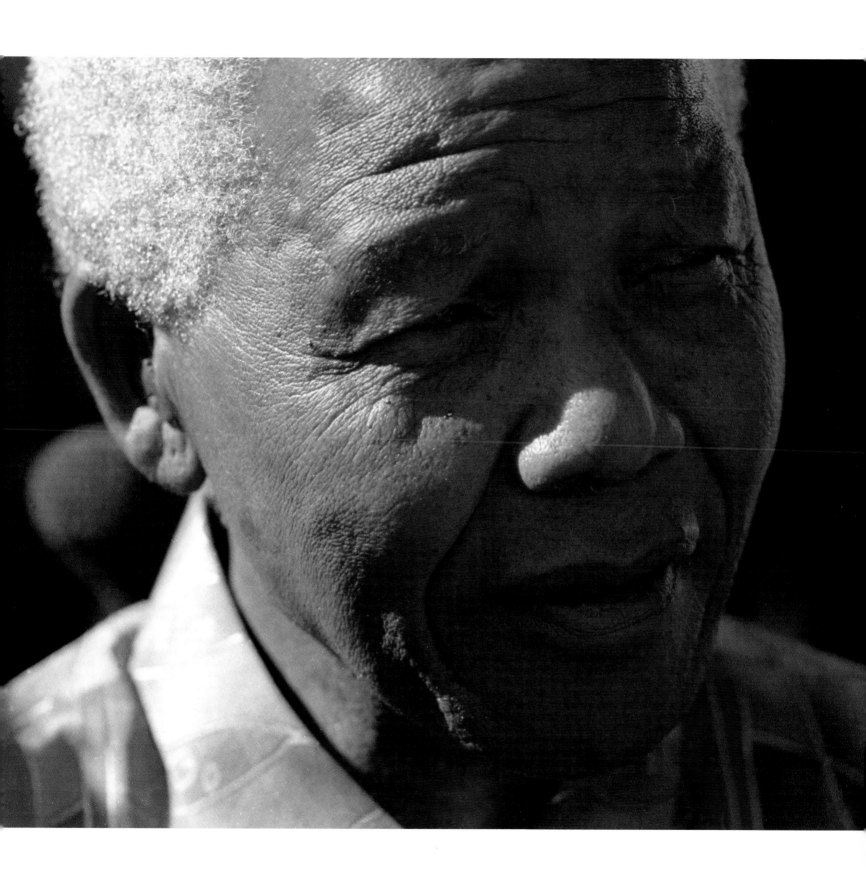

POLITICAL COMMUNICATOR
ALISTAIR CAMPBELL

In a world

often defined purely by the here and now, **he reminds us that nothing good, or worthwhile, comes easy.**

In a world often defined by the pursuit of self-gratification his presence and achievements tell us **that real fulfilment** *comes from* **striving to make a difference,** *and that* **real leadership** *is about* **setting a course** *and* **sticking to it whatever trials may come along the way,** *and in* **his humility** *he reminds us that* **the work of great men** *can only be* **successful** *with* **the support of great people** *whose names we may never know but* **whose humanity we never forget.**

STOCKBROCKER
JERRY LEES

To *Nelson Mandela,* **self discipline in all aspects** of his personal life *has given him* **an inner strength** *to see through all those years* **struggling against white domination and for freedom in South Africa.**

Incarcerated for life, many men *would have considered* **compromising their principles** *in exchange for early release, but Mandela never took that route.*

That **determination** *and those strong* **unwavering principles** *led him first* **to become the symbol of his people, country, and equality.** *But beyond that determination,* **his amazing example, never bitter, never lowering himself to answer racism with racism, helped him to establish a nation** *and* **become a symbol of humanity** *and* **peace.** *We can all learn from those two strengths,* **self-discipline** *and* **capability to forgive.**

PROFESSOR OF PHILOSOPHY
AUTHOR/BROADCASTER
A.C GRAYLING

Nelson Mandela fought for justice, and won his battle by courage and fortitude. When he was released from prison he showed the greatness of spirit – the 'magna anima' – which Aristotle said is the true mark of the moral hero. Nelson Mandela is the greatest moral hero of the twentieth century, and an example to anyone who wishes to rescue the words 'justice' and 'peace' from the clutches of mere rhetoric, and make them apply to reality.

BASS PLAYER
COLERIDGE GOODE

First *of all his* **bravery, stoicism** *and* **belief in a righteous cause,** *and the* **enormous amount of patience** *to combat the assault of anti-forces.* **Complete belief** *in* **one's cause, forbearance** *and* **the ability to withstand violent attacks** *of all sorts and almost as the bible says to turn the other cheek when necessary.*

The understanding of human nature, *what makes people tick,* **how to harness people's goodwill.** *Thinking about the welfare of all your neighbours and friends, harmony in society. Avoidance of discord,* **the overriding thing is the ability – the truth.**

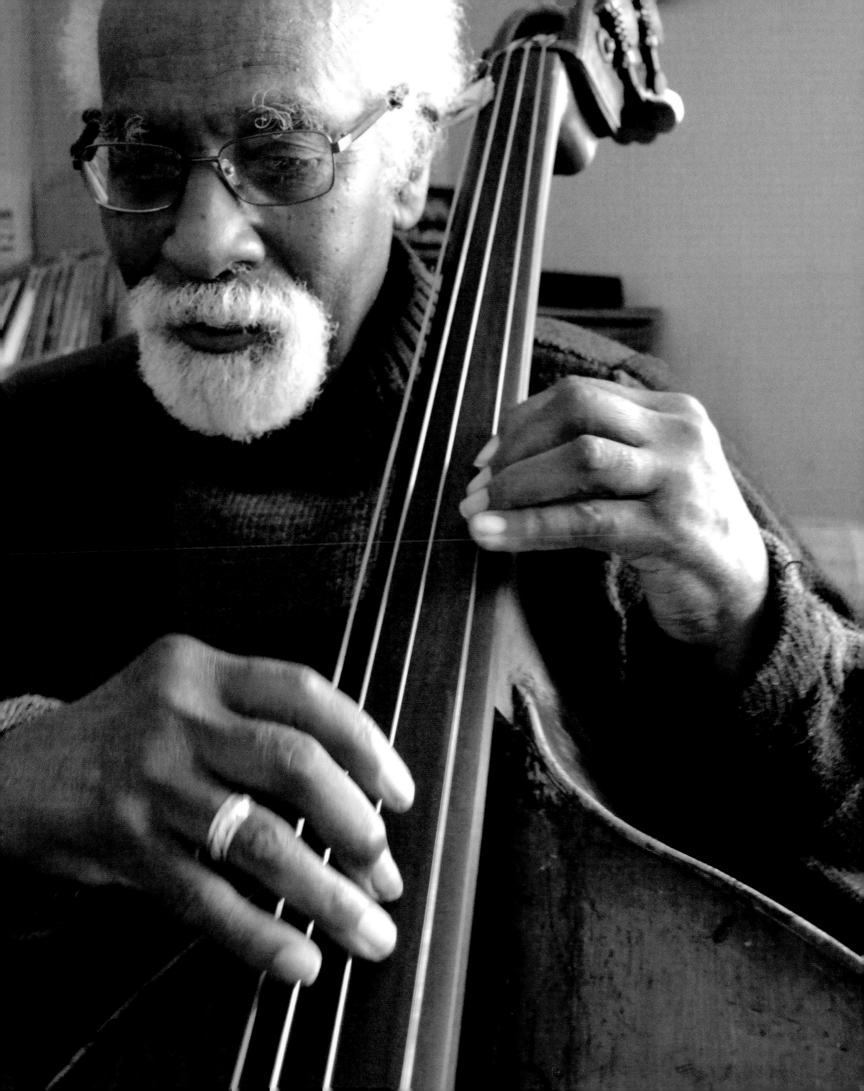

SINGER
DIANA ROSS

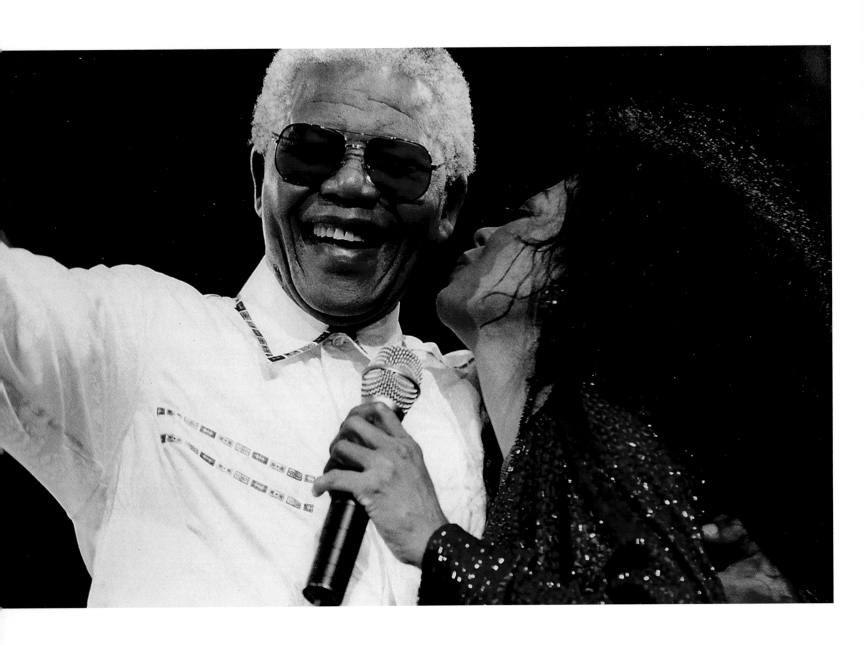

*That there are **powerful Possibilities** in **Thought** and, with* **Faith**, *there can be* **Peace** *and* **Happiness** *in Our World.*

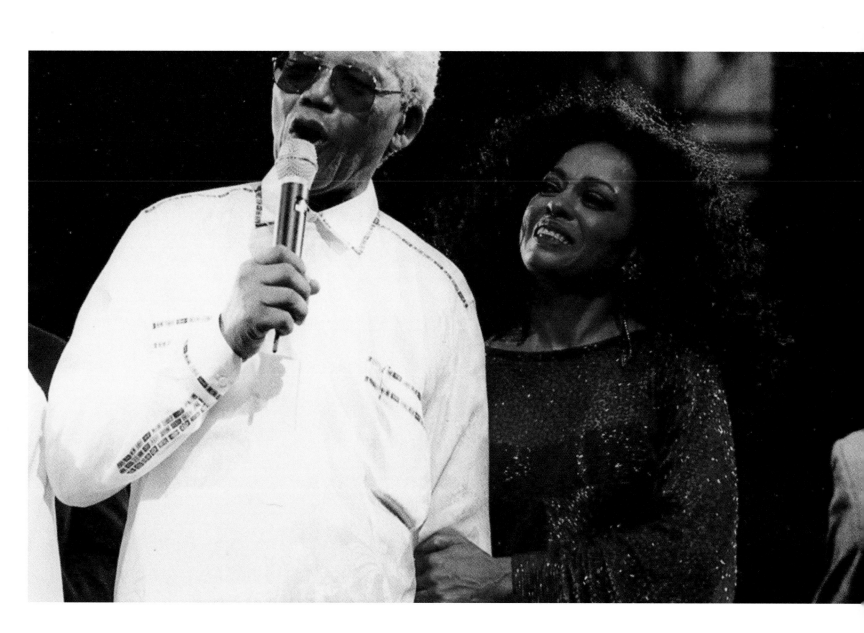

FINE ART LECTURER/FILM DIRECTOR
JOHN WRIGHT

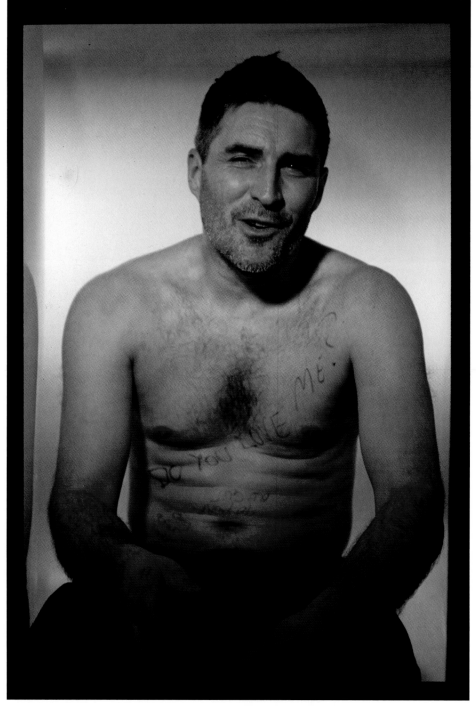

No man *has the right to ask for what he asked,* **yet we all said –** " yes he is right" *and* **history said if we break all our rules and believe, things can change** *(I wish it worked with others).*

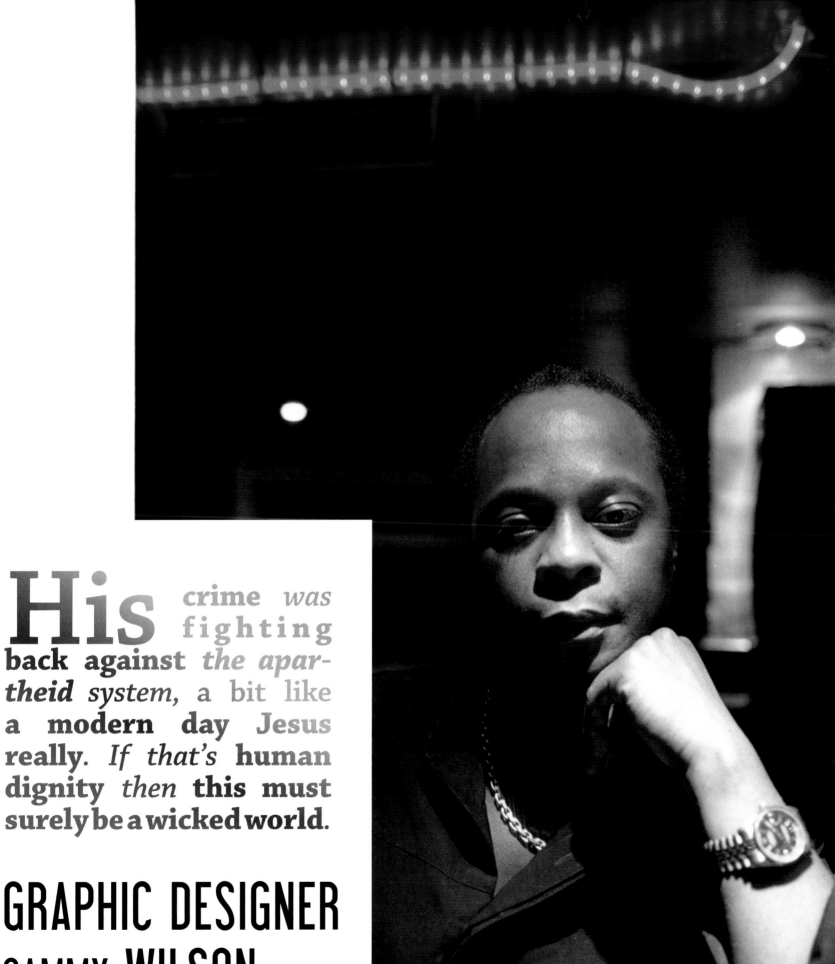

His crime *was* fighting back against *the apartheid* system, a bit like a **modern day** Jesus really. *If that's* **human** dignity *then* **this must** surely be a wicked world.

GRAPHIC DESIGNER
SAMMY WILSON

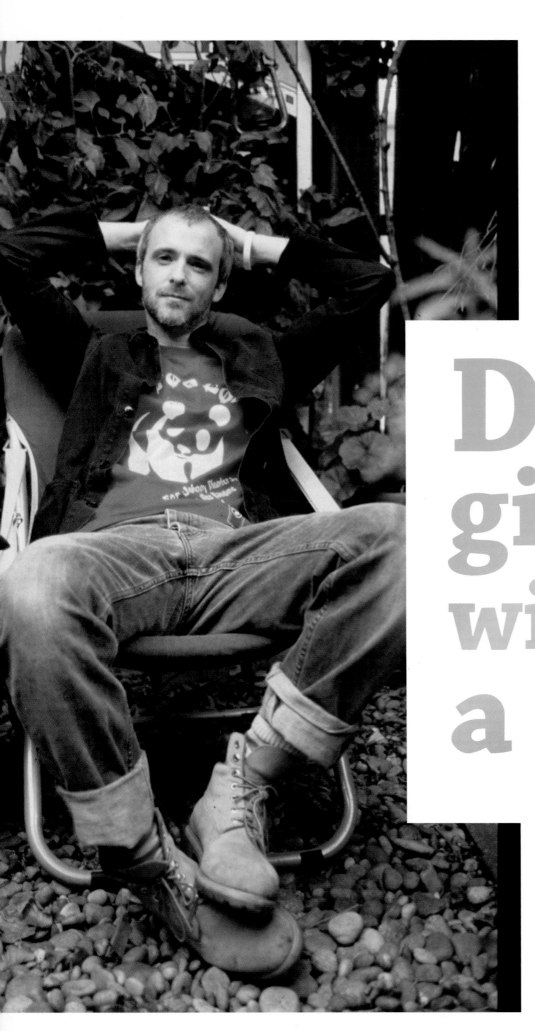

MUSICIAN
FRAN HEALY TRAVIS

Don't give up without a fight

SHIATSU THERAPIST
SU-MAN HSU

Be **courageous** *and* **stand up** *for* **what you believe**. *Show love to yourself and* **give to others**.

Don't be frightened to go beyond.

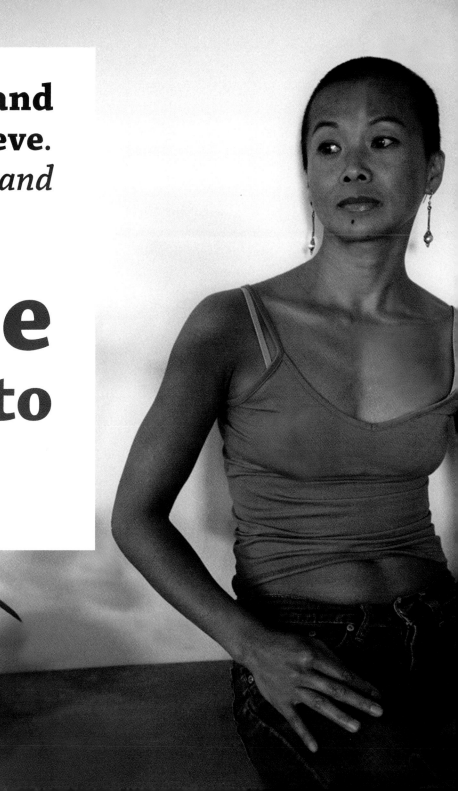

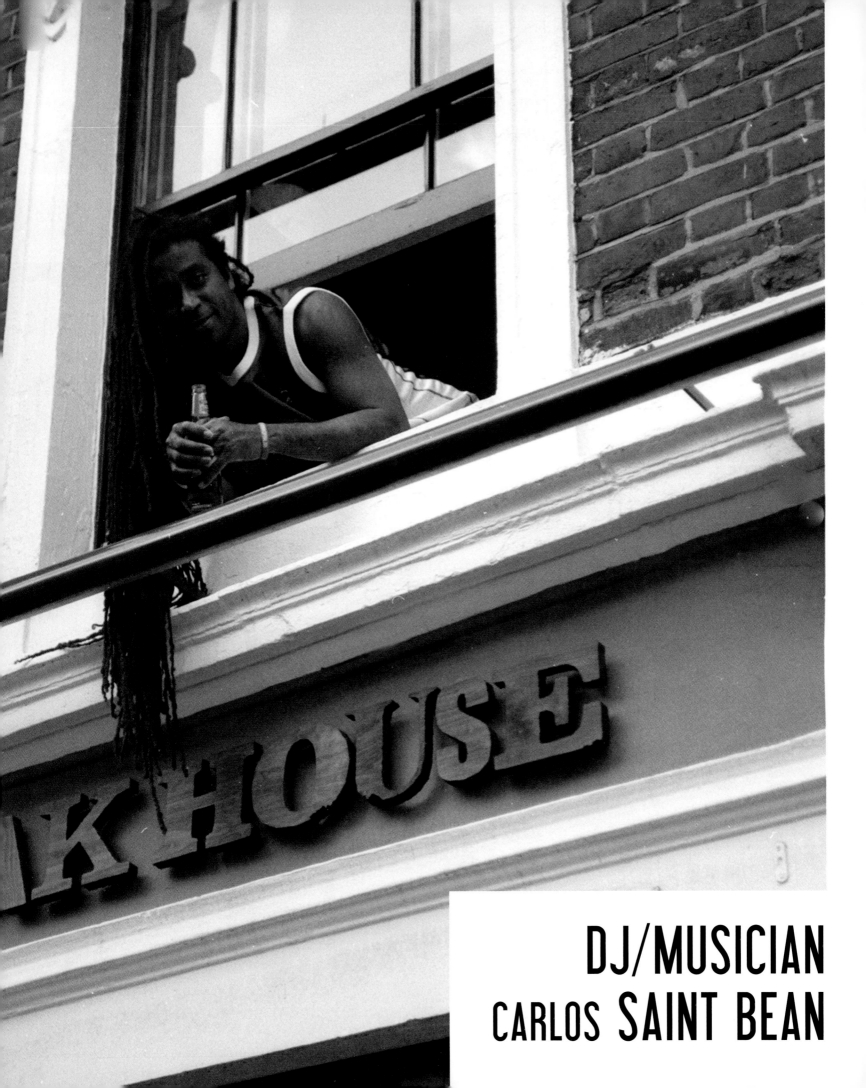

DJ/MUSICIAN
CARLOS SAINT BEAN

Nelson looked into my eyes. *Only days after his release, he honoured the city of New York with* **his first foreign visit**. *Lining the streets from Tribeca to Soho with one million others,* **I was there**. *My old home of New York and my new home London are the only cities I know of that are a true amalgam of the population of our planet. It was a warm sunlit perfect day and it looked and felt like the world was walking downtown. My best friend Charles and I were firebrands on fire. A Greenwich Village poet-musician and a Soho painter.* **We were dreadlocks and visceral and schooled in all the modern masters. Marcus, Mahatma, Malcolm, Martin and Mandela.** *Nelson was for us* **the prophet in a direct line of ascension.** *For those of us in America of our generation, not quite old enough to remember fully those other great men,* **Nelson was for us.** ▶

Our own freedom struggle *came full circle with him. He was a return to the days of Frederic Douglas and Harriet Tubman. He was just the same.* **He made us love, and we loved him. We painted the canvases and wrote the songs during his captivity. We marched the marches and sat the sit-ins and talked endlessly of how the world would change when his cell door opened. And it did.** *Just imagine, in our world of kings, presidents and prime ministers with untold wealth and power, a modest, quiet man walked from Robben Island and humbled them all, and we watched them pay homage.*

To think that such things were possible, that they happened in our lifetime…a black man. *So we lined the streets and waited. To cheer and wave and pour out every ounce of emotion we could. To try to give a little something back.*

There was a joyous noise to the south of us and we knew he was just beyond view, but time slowed almost to a stop and it felt like forever. Two decades of rallying for his freedom and this felt like forever. We were just on the corner where the avenue turns onto the street to City Hall with hundreds of other hardened New Yorkers, shoulder to shoulder, happily invading each others personal space.

For maybe the first and last time in our urban lives, kissing and hugging total strangers, New Yorkers making eye contact!

The stuff of miracles.

All in what seemed like slow motion, the vehicle drew near. The throng on either side of the avenue was a wall of sound as the carriage crept along to allow Nelson time to acknowledge as many as he could. **But there he was, yards away. Perhaps the only man ever, crossing boundaries of race, religion and region, that the citizens of this world would want to enthrone. He was the king. As he turned our direction, waved and smiled the famous smile, our corner surged forward and upward.** *Not in a riotous way.* **We simply rose and fell with his hand.** *As he smiled wider and waved higher, the lurch of the crowd lifted me of my feet and held me there. It was comfortable, warm and safe. The cheer was deafening to what felt like silence.* **I was levitated. Then he looked my way. And we were eye to eye. A great, liberating roar from my soul** *and then the carriage turned and drove away. Charles and I, who both talk too much, had nothing to say. We saw with our own eyes what the world could be, and would be. There would always be canvases to paint and songs to sing. So we just walked home and smiled at the sky. Charles is an ocean away now and that day is distant.*

This world is still so far from the one that Nelson Mandela promised. But not because he lied. But the world needs more of him, but unfortunately there will only ever be one of him.

An *inspiration*

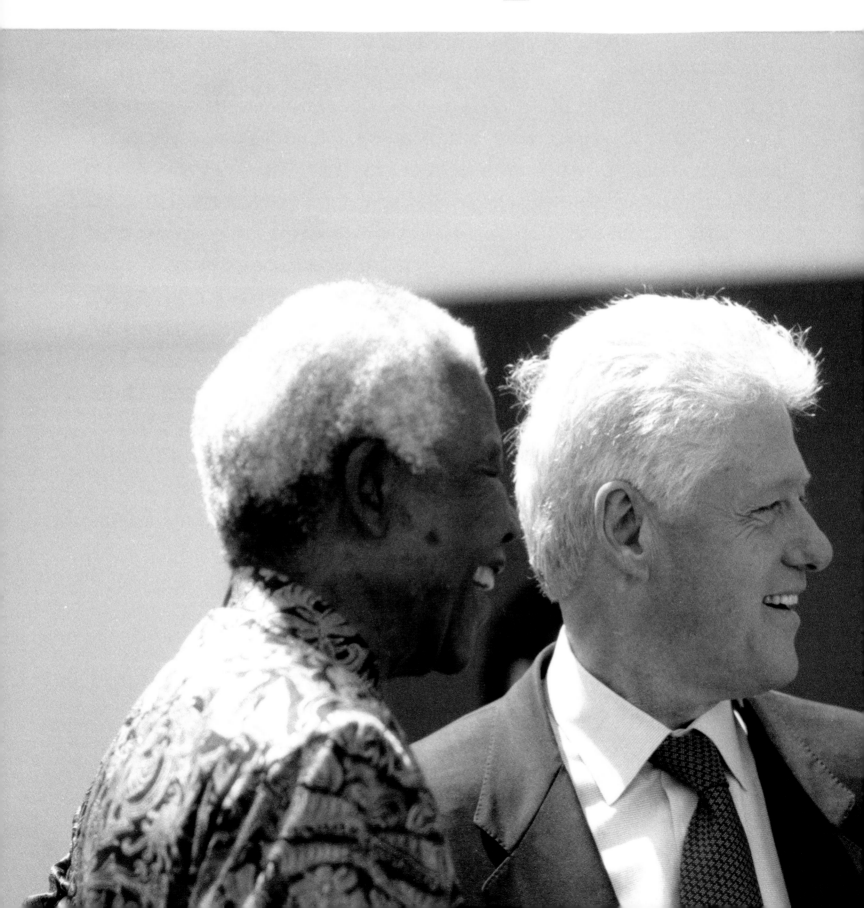

to **mankind.**

MODEL
KATE **MOSS**

I can only say the world would be a better place if only more people thought his way and learnt that communication is the key to embellishment of our planet. *Setting people free is allowing ourselves to feel whole in terms of* **unity** *for all.*

MANAGER
DELPHINE PREAU

His *eyes* twinkle *with* kindness, strength *and* Peace.

COOK
MONICA RIVRON

Forgiveness:
no matter how vile the regime, *how* **deep the insult,** *how* compelling the desire for revenge.

And **humour, without which** the world is intolerable.

BROADCASTER/JOURNALIST
SIR MICHAEL PARKINSON

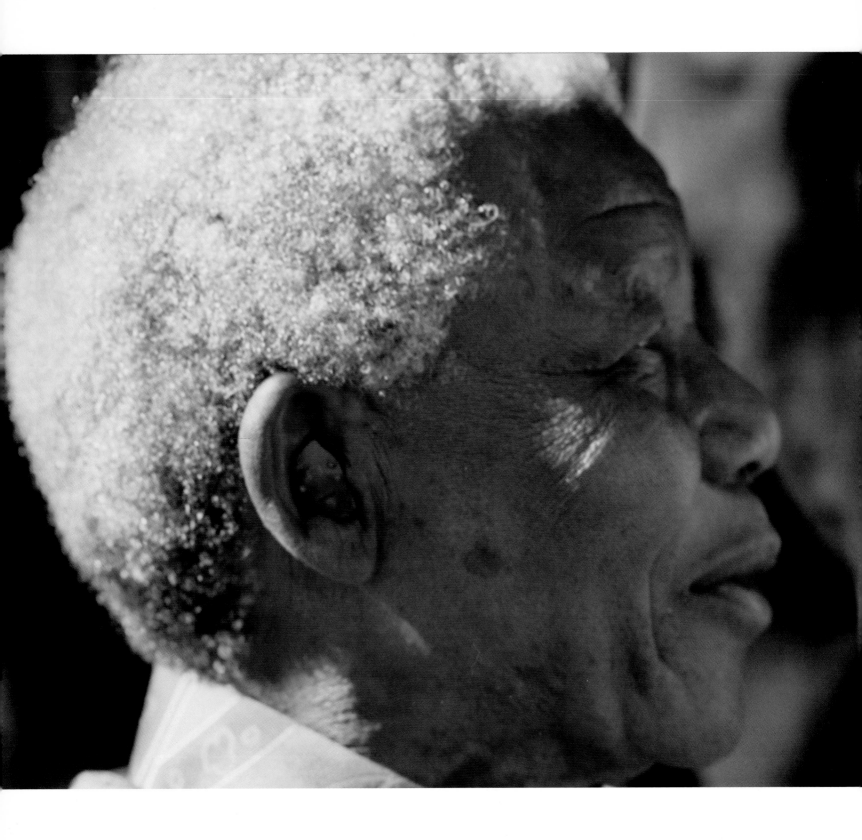

SINGER
CELINE DION

Through his personal sacrifices and beliefs, Mr. Mandela has shown the world that **freedom and civil liberties are among the most important aspects of our existence.** *Through his* **generosity,** *his* **leadership,** *and his* **love,** *he has demonstrated that the children of the world,* **are our greatest asset, and we must do everything to nourish them, and protect them.**

PROJECT MANAGER
STUART ROUND

SOUTH AFRICAN HIGH COMMISSION

There are so many things one could say about Nelson Mandela, he is the personification of the South African struggle for freedom and **an embodiment of the best in human nature. His life raises a question as to whether we hold our beliefs, or whether in fact our beliefs hold us.**

There are some fundamental principles of human dignity and compassion that so go to **the core of our humanity** *that to compromise them would be to compromise the very essence of one's existence.*

To me, Nelson Mandela was an inspiration.

As with all the formerly oppressed South African people, his stoicism and dignity in the face of a cruel and brutal oppressor was incredible. When threatened with the death penalty, the choice for Mandela and his comrades was between a physical death, or a death of identity, morality and self respect. I was so moved, that when asked to smuggle weapons into South Africa for the ANC I too was prepared to risk my life alongside them; there was no other choice that I could make that would allow me **to continue with a belief in my own integrity** *in the face of evil.* **This is the real power of Nelson Mandela, to truly gauge his impact on the world you not only have to count his own deeds, but the deeds of the thousands of people inspired by him.**

In a world which is ever more cynical, and ever more materialistic, **people like Nelson Mandela remind us of the true value of our own lives, and those of other people.**

Nelson Mandela has taught us that freedom of humanity is worth suffering for. The dignity and peace shown by Nelson Mandela is a source of inspiration for me. Stand strong for what you believe in.

HAIR/MAKEUP ARTIST
JAY TURNBULL

"*I believe society can learn many things from Mr Mandela. Chief among them is what it means to* **lead**, **love**, **sacrifice**, *and believe that you can* **reconcile the issues**, *that for so many years, have impeded the unity, growth and prosperity of South Africa.*"

ACTOR
DENNIS HAYSBERT

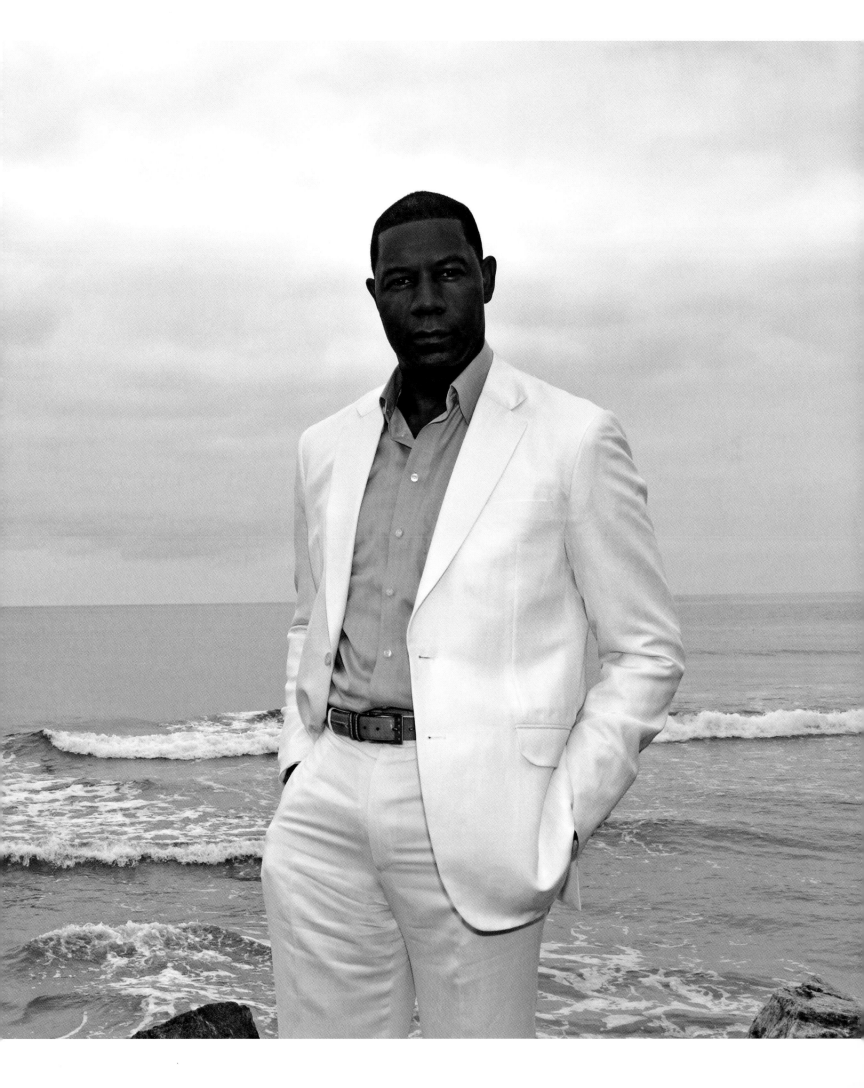

PATIENCE

ACTOR
CLIFF PARISI

CONCENTRATION

and then some ...

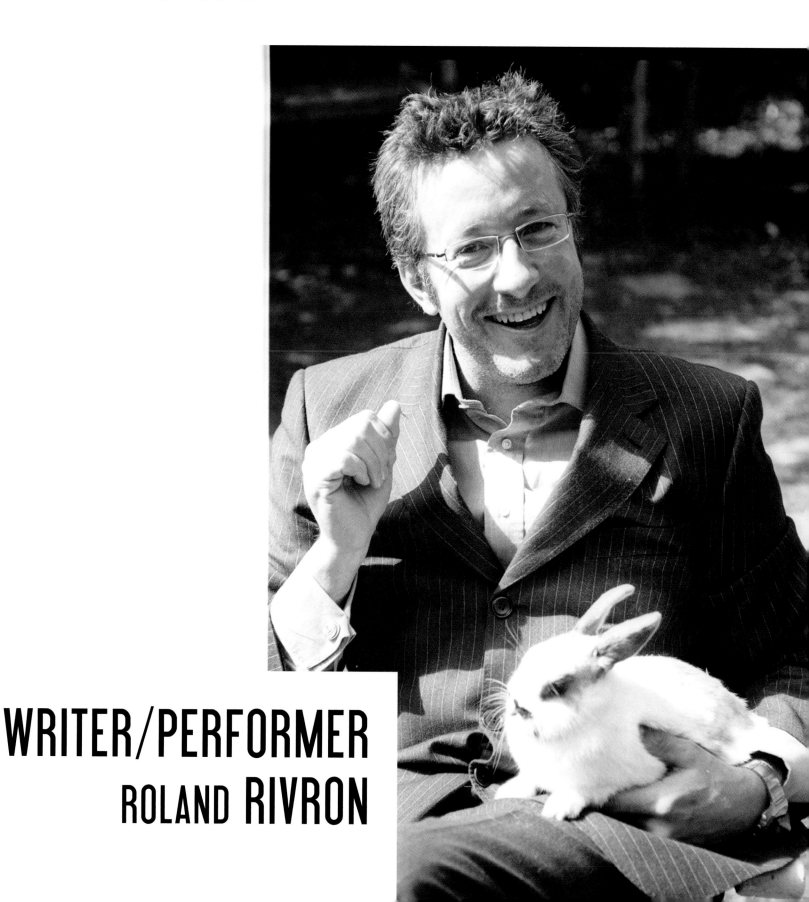

WRITER/PERFORMER
ROLAND **RIVRON**

ENDURANCE

COMEDIAN AARON BARSCHAK

EMPATHY

I don't believe people understand **empathy** *anymore and if they do they don't employ it.* **Because it sounds too similar to sympathy, because no one really wants to receive or give sympathy.**

SPORTS THERAPIST
KARATE INSTRUCTOR
HORACE ARCHER

RESTAURANTEUR
ARNIE UNISEN

FORGIVENESS

WRITER
RANDIE McWILLIAMS

Much more *than precepts, the lessons most likely learnt and put to practice are* **those taught by example.** *To be human, and to be able to live* **"forgive them, for they know not what they do"** *requires wisdom that understands* **the healing strength of HUMILITY. Nelson Mandela is wise enough to be humble.**

First, that cooler heads is always the first step. That **forgiveness is always an option, though no one can ask you to forget,** *and that in the bigger picture all these things,* **being without some humor can drain you of your humanity.**

ACTRESS WHOOPI GOLDBERG

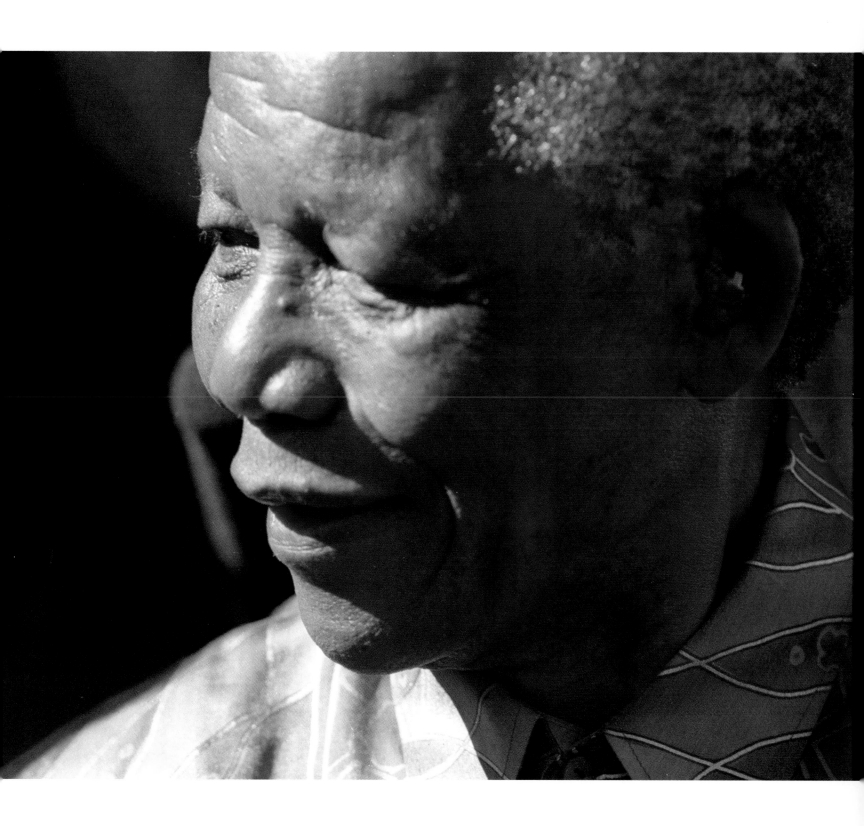

TELEVISION
PRESENTER
RICHARD LINDLEY

I met Nelson Mandela when he was out of jail but had not yet become South Africa's President. *Our interview (for British television) took place at the ANC offices in Johannesburg at seven o'clock in the morning; there were no minders,* no press officers, and even his secretary left **Mandela alone with me and my camera crew.**

I greatly admired **his independence of mind, the sense of self- reliance** *that had seen him through so many years of imprisonment.* **Yes, he was a party man, able to work collectively with others, but his fundamental strength** *seems to me* **to come from a determination to be true to himself and his principles.** *That is why that, of all the statesmen I have met,* **Nelson Mandela is the most impressive. He is a man who has never needed the trappings of power, never needed people to tell him he was important.**

He has not always been right, but his determination to do the right thing as he sees it made him in the end an irresistible force for good.

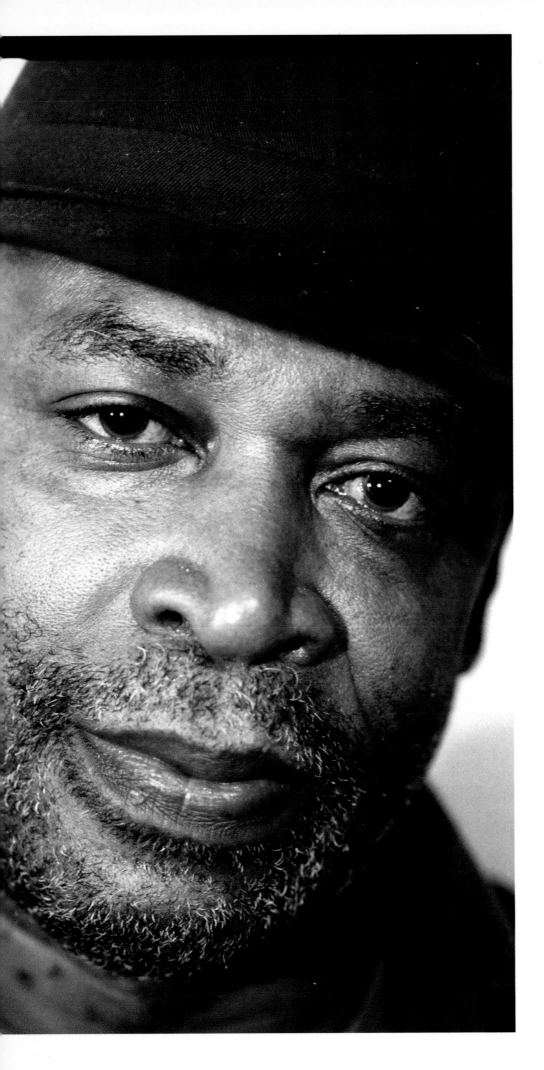

To attempt to put in words the remarkable achievements *of Nelson through* **his lifelong adversity could be compared to an iceberg.** *Similarly what he has taught us is that if we would only look beneath the surface we would indeed discover that there is greatness in each and every one of us. Such that* **we would want to embrace each other and thus treat each other as equals.**

SELF EMPLOYED
HENSON ROUSE

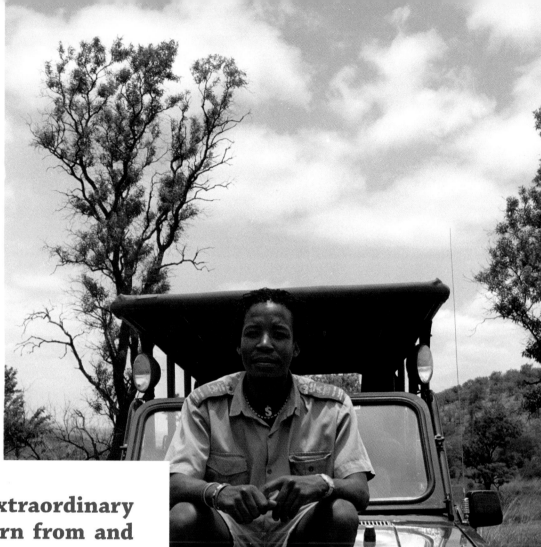

Nelson Mandela *is* **an extraordinary man**, **that we can learn from and that we have learned from.** *There is not one country or one person in this world that can say today they didn't learn anything about* **peace from Sir Nelson. Freedom is a right each person has, freedom is what Sir Nelson has given to each individual South African and not just South Africans.**

Living together no matter what race, *what age is what is going to make this world a better place* and that's what I think Nelson Mandela is trying to show everyone.

GAME KEEPER
PETER MOUTLOATSE

STUDENT: AGE 12
SHERRIDAN GRAHAM

I think we could learn **to be more forgiving from Nelson Mandela.** *People put him in a prison for 27 years and* **he wasn't angry. He accepted their apologies, accepted that they had done something wrong, and then went on to make the world a better place.** *He was intelligent enough to forgive the people who treated him so badly. He then went on* **to campaign** *for rights for black, Indian, Chinese, everyone.* **He wanted fair rights for everyone. He believes in peace and fairness.** *If everyone was fair, and fought their hardest to keep peace, then the world would be so much better.* **He is one of the most respected people in the world, but he still doesn't get enough respect. He is also very modest,** *which is another good virtue.* **I say good luck to you Mr Mandela, on your long campaign for equal human rights around the world and to abolish racism.**

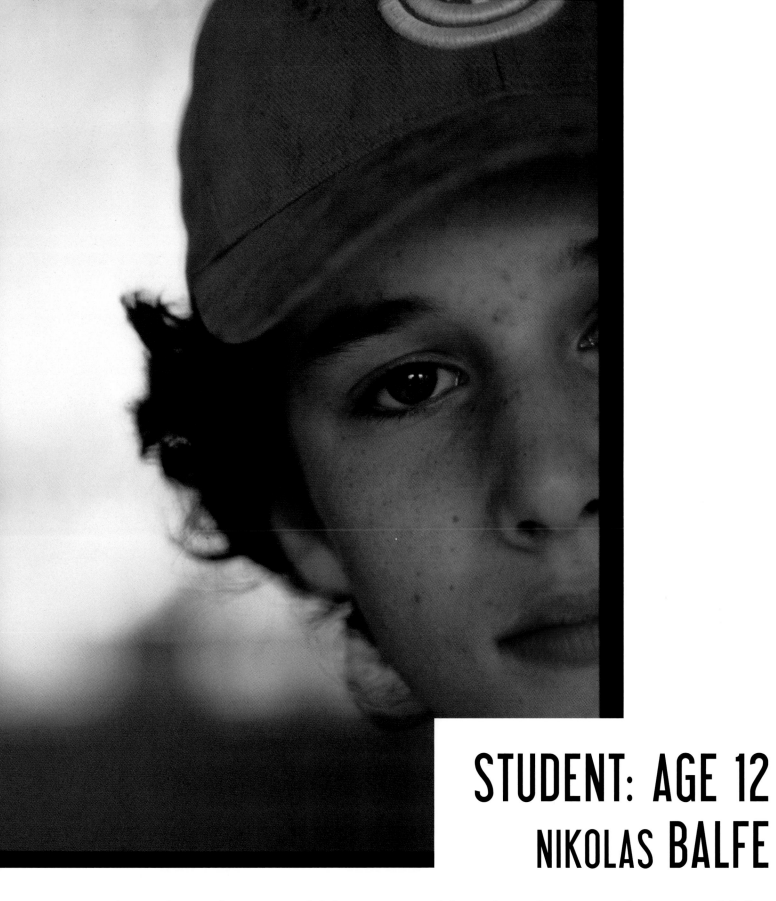

STUDENT: AGE 12
NIKOLAS BALFE

Without him there would be **no world today,** *because there* **would be** no relationship between black and white people today. **He taught** us how to make the world a better place, **by bringing us closer** together. He taught us how to forgive people, **by forgiving for us.**

RETIRED
JOHN MILLS

In a certain part of South Africa Mr Mandela was well known and liked, he was their champion. *Since being home, and reading the papers* **he mastered out to be a man who loved his country, and did a wonderful job up to the time he retired.** *I don't think the people of South Africa will ever find another man like him.* **They have got to be proud of him, so they should. May he enjoy the rest of his life.**

STUDENT
SOPHIE O'NEILL

His dignity, faith perseverance, dedication *and* **love** is an inspiration to me that **peace** and **hope are worth believing in and working for.**

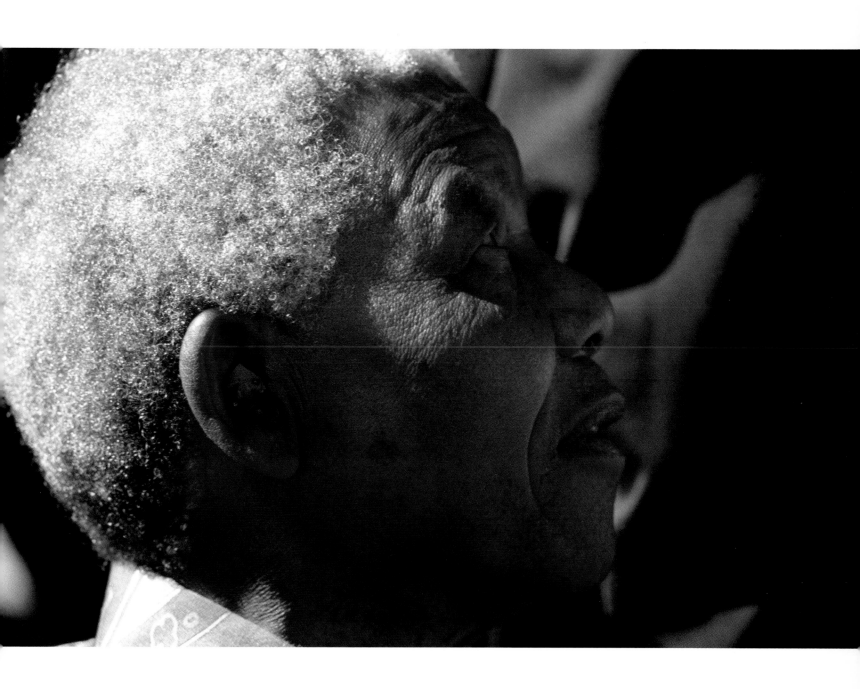

BAR TENDER
RONAN PRIMO

Surely the most inspiring public figure of my lifetime, no one could teach us what "standing up" means better than **Nelson Mandela.**

RETIRED (SENIOR LECTURER)
SOL SAUL

The most important thing Mandela gives us is the gift of **tolerance and forgiveness** in situations where revenge is the norm. **The truth and reconciliation system is a model for the world to consider – and adopt.**

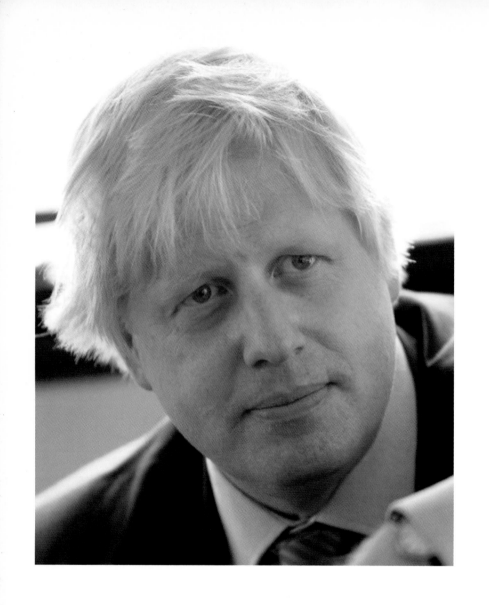

MAYOR of LONDON
BORIS JOHNSON

Nelson Mandela *is an* **international hero.** *His lifelong struggle for* **freedom, fairness** *and* **fraternity** *has inspired generations. Mankind can learn much from his values and virtues – his* **humility, discipline** *and* **compassion**. *He simply emanates* **goodness** *and* **grace.**

Everything !

Nelson Mandela has taught us **unity**, **he has given many a reason to live.** *He, as one man, stood up for the rights of his people and for the world. He has shown us* **forgiveness, love** *and that* **there is no difference from one person to the next. He has inspired many from his heroic deeds,** *but there is still much more to be learnt.* **From Nelson Mandela everything can be learnt, and there is that powerful message in between.**

STUDENT
JADE POOLE

SINGER
BEVERLEY KNIGHT

I would say that we have learned the real meaning of **grace** *through Mandela's example.* **A man who rose from prison to presidency despite all the odds stacked against him, and having reached that pinnacle bore no malice toward those who had imprisoned not only him but an entire nation for so long.** *He instead pressed forward with his* **reconciliation** *and* **healing** *agenda. I do not know of any historical figure in a similar position to have done the same.*

TRULY REMARKABLE.

RECORD PRODUCER
KEITH CLAYTON

Mr Mandela showed us how to forgive. With clean hands and a pure heart, one can learn from mistakes others have made in their lives.

The consciousness of the world woke up when Nelson Mandela walked free from prison.

I suspected he would be bitter after 27 years but I was wrong, he is **Brave** and **True to his beliefs, we need more like him.** *Now in his retirement* **he still encourages people to work for Justice** *and* **an answer to the HIV/ AIDS epidemic.** *With global communication and commitment we could make Poverty History.*

An interesting fact I found, his **original first name Rolihlahla could be interpreted as "troublemaker"....... say no more.....**

MUSICIAN
JOHN TURNBULL

AUTHOR/MEDIA CONSULTANT
CAROLE STONE

I *think the way Nelson Mandela has lived his life* **teaches us** *a fundamental lesson:* **to look forward not backwards.**

What's important is how we cope with what life throws at us.

Mandela, rather than bearing grudges, is doing **what he can with the time left to him to bring harmony to the world.** *I have been told by many journalists who have met Mandela that* **they have been impressed by his modesty and grace. Even those like myself who have never met him are nevertheless inspired by his smile, his sense of fun, and his hope for the future of mankind.**

As a young woman in my teens Nelson Mandela influenced my life from across the ocean. Today more than ever our young people still need his influence and guidance. Madiba should be as important to them *as a personal stereo, a favourite fashion designer or celebrity; but hopefully he will become the positive voice in a headset, a designer of dreams; and a celebrity?*

Well he already is.

Nelson Mandela has taught society a new way to live, a reason to believe that anything is possible, to realise that humility is strength not weakness, patience brings rewards and most of all to be tolerant to one another.

My Fondest Memory
November 2003

DESIGN CONSULTANT
AVIS CHARLES

A helicopter overhead, I look towards the sky, I watch it land, the dust settles, the door opens, a fragile but strong figure emerges, descends the steps, my breath stops, a tear drop falls on my cheek, he waves, I blink and wake up: yes it's true, my mentor, my role model is walking towards me – Nelson Mandela, Madiba. 46664 concert.

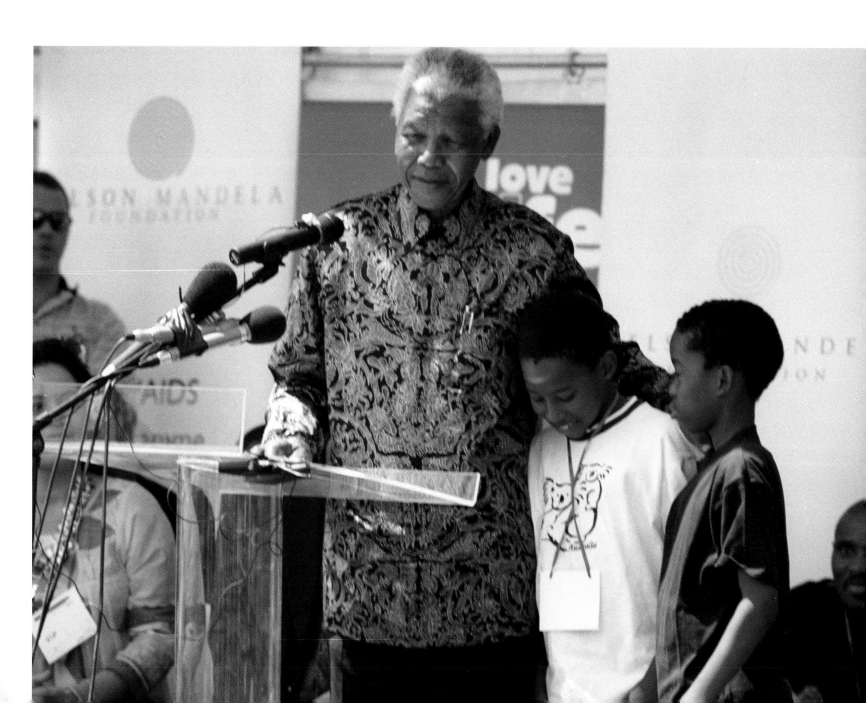

ACTOR/WRITER
STEPHEN FRY

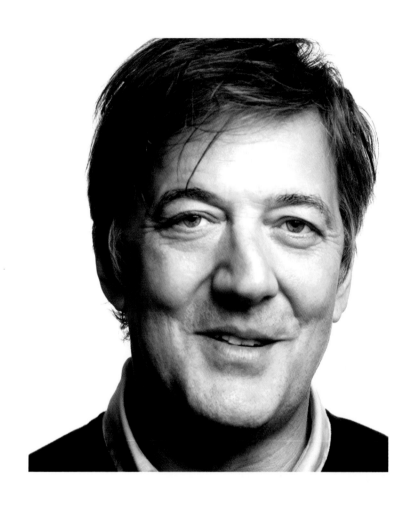

PATIENCE
STRENGTH
PEACE
BELIEF
INTELLECT
CONSTANCY

HUMANITY
FORGIVENESS
HUMILITY AND
STRENGTH

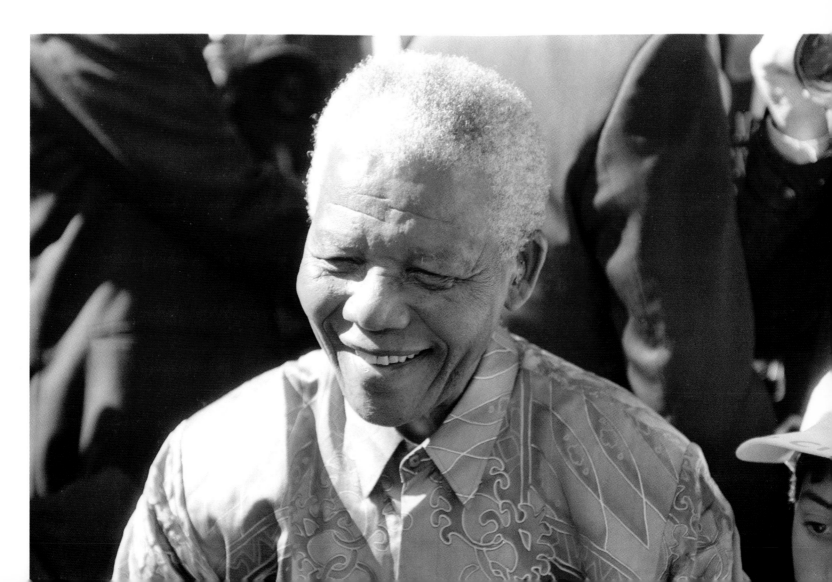

STUDENT/TRAVEL
SILKE BARTELS

I hold Nelson Mandela to be one of the most admirable people in the world. **The selflessness and self sacrifice** *he displayed in support of his convictions whilst rejecting retribution and embracing a belief in justice as the means to this end seems almost unique.* **The incredible strength of will he demonstrated and which remained unbroken even under imprisonment and solitary confinement.** *The will to pursue his struggle whilst in prison and managing to resist offers of conditional release. Suffering for his fellow man.* **His achievement in changing the world after being locked away for almost three decades.**

He was able to prove that it is possible to bring about change without resorting to violence.

What reserves of endurance and what depth of belief in good must he possess, in order to have been able to forgive his long standing enemies, who murdered, raped, abused, humiliated and oppressed. He gave them the opportunity to express regret, and encouraged forgiveness. He not only changed his own country, but he won a victory against race discrimination worldwide.

I consider him exceptional and I believe that the recognition and tributes he receives from around the world are a beautiful expression of gratitude!

Thanks Mr Mandela for being who you are!

DOCTOR ZOE HAWKINS

Never underestimate the power of a man who knows right from wrong – and is brave enough to do something about it. **Nelson Mandela has proved that one voice can change the world. He inspires us not only to look inwards and believe in ourselves, but also to look outwards and stand up for those beliefs.**

Seeing Nelson Mandela at the Make Poverty History rally in Trafalgar Square **was such a privilege. His speech was powerful, passionate and motivating; I found it incredibly moving** – I think everyone did. I came away **filled with hope for the future and a sense that we really could make a difference.**

What an inspiration!

Many people

in Britain remember exactly what happened on 16 September 1992. Black Wednesday saw the then British government's handling of the economy go into freefall, and the pound crash out of the Exchange Rate Mechanism. But the reason that date is imprinted in my memory is different: I rose at six in Pretoria to interview Nelson Mandela.

At the time, I was presenting a weekly international affairs program on British television. Mr Mandela had agreed to be interviewed as long as we turned up at his office at 07.30. His Robben Island years had accustomed him to early mornings! Two years after his release, he was already leading the African National Congress Party in its mass action campaign for a constituent assembly and a transitional government, and an end to the culture of state violence that had dominated the country for over 40 years. So international support and understanding were key elements to his plans - hence his agreement to be asked questions by a British journalist.

To this day, he remains the most impressive politician I have ever interviewed - and that includes some very big names.
He was civil, he answered the questions clearly, courteously and comprehensibly - and he gave us 40 minutes of his precious time. I quizzed him how he could recommend work-to-rule protest action while at the same time lobbying the wider world for inward investment into his country. He explained that life tends not to allow simplistic, polarized responses to vicissitudes, and that harmonizing strategies promised the most favorable outcomes.

So, for instance, he understood that nationalization would not be seen by the wider world as the correct means of redressing South Africa's economic imbalances. And despite his very public criticism of then President de Klerk and the NP, his modus operandi meant that change in his country was incrementally and rapidly achieved, to the lasting benefit of millions of citizens, and he and de Klerk resumed negotiations the week after I had met and interviewed him.

So I would identify the values he demonstrated and embodies to this day thus: he shows a fundamental respect for the democratic political process (and the role the media plays in that process) which he manifests through never patronizing his opponents, nor the voters.

He leads from the front, and does not shirk from speaking the truth, however unsettling or complex it might be. He has improved everyday life for innumerable people through his commitment to justice, and offers an example of how one man can make a real difference in a naughty world. His generosity to people beyond his personal life and experience is extraordinary.

It was so good to meet him and experience it for myself.

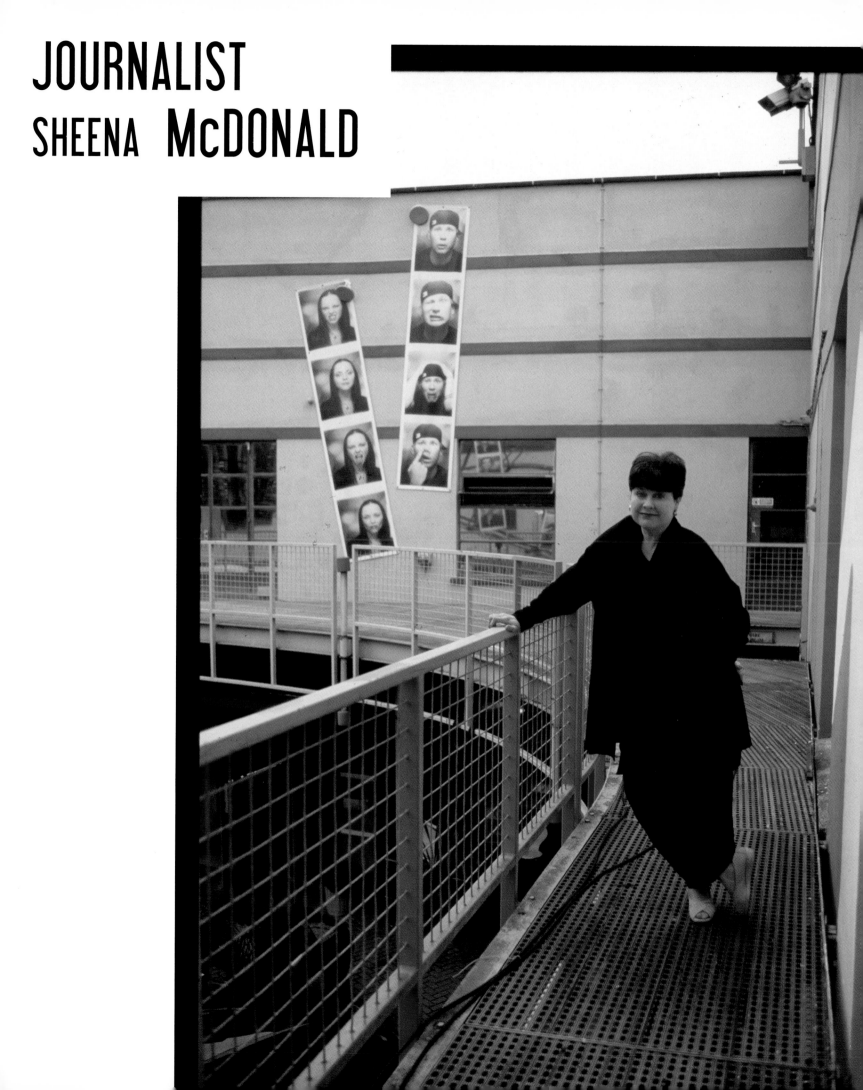

JOURNALIST
SHEENA McDONALD

SANGOMA HEALER
T.N. NDEBLE

Umhlaba ungafunda ukuthelelana Ukuzithemba ubulungiswa Ukuzimisela kokholelwa likho Ukuze uphumelele empilweni

The world can learn to forgive and let go of the past, and always be faithful in what you are doing, and always put justice first, and have strength and courage in what you believe in. And we can all be a success in our lives.

PSYCHIC/SANGOMA HEALER
SARAH NAGAR

Forgiveness and unity no matter the colour of the skin, our spirits are one. Our ancestors are joined in spirit.

MEDICINE MAKER
MUYO NDEBLE

If you believe never give up keep the faith and think positive. Mr Mandela waited for 27 years for

FREEDOM.

ANTIQUE DEALER
SOLOMON SALIM

Nelson Mandela *is a man who is* **spiritually** *and* **mentally at peace.** *He wanted* **freedom** *and* **justice to people** *and* **for people to be treated equally.** *Although he was sent to prison he came out* **to be the first black president of South Africa and was awarded the Nobel Peace Prize in 1993. He led the struggle to replace the apartheid regime of South Africa with a multi-racial democracy and is still recognised as one of the world's most revered statesman.** *In my opinion not many can match up to the man he is and* **I have great admiration for his beliefs and thoughts.**

FREEDOM, FREEDOM, FREEDOM.

Nelson Mandela is no doubt a charismatic leader and person of this century. And today every civilised person of the world believes and accepts him as an icon of peace, but he reached this place, because of his commitment to his goals, continued struggle and belief in peace, tolerance and democratic process and struggle.

Every person and leader can learn the lesson from Mandela's life. The lives of Yasser Arafat and Mandela are good examples for the leaders and politicians – one believes in the power of gun and terror and the other believes in the power of tolerance and democratic process, and the world witnessed in that Arafat failed in his mission, while Mandela achieved his goal in his life. Nelson Mandela is not only the leader of Africa, he is the leader of humanity, of all human beings, regardless of race, colour, nation and religion.

Nelson Mandela the name is peace.

SHOPKEEPER
GHAZAN NAWAZ

"A saint is a sinner that keeps trying" Mandela.

Mandela taught us by his own example that **forgiveness dignifies mankind.**

He carries it in his face like other great spiritual wise men.

ACTOR
ANNA NYGH

The ultimate elder statesman. *A man whose experiences would have scarred any normal person's personality and judgement, but* **who has actually remained perfectly balanced and whose opinions the whole world looks to.**

CAMERAMAN (BBC)
STEVE HOLLOWAY

113.

SCHOLAR: AGE 6
ZARA BRISLIN

He was stuck in jail for a few years. **I think he is a nice person, because I do!**

SCHOLAR: AGE 11
MILA BRISLIN

Nelson Mandela **has shown us that everyone is** equal no matter what **race we are or the religion** we belong to. He has **changed the world today.** He gave his whole life **up to gain freedom for his** people and at the age **of 87 he is still fighting** for the cause of AIDS.

MOTHER/ HOMEMAKER
CLEA BRISLIN

I never thought I would see Nelson Mandela released from prison in my lifetime or my children's. *Everything felt hopeless growing up in South Africa.* **The apartheid regime** *crept through every aspect of society and* **as a white person I felt sickened by the whole system. Mr Mandela became the symbol of hope…** *we anticipated widespread violence and bloodshed as a means to overthrow the Nationalists and bring in democracy.*

Many people were incarcerated, tortured, killed, humiliated and suffered as a result of the force used by the state, **but many more lives were spared by Mr Mandela's negotiations that led to his eventual release.** *After all those years locked up on Robben Island he was willing to let the very people who were responsible for his incarceration* **hand over power with some dignity. We** can all learn from **his humaneness and capacity for love** and forgiveness.

The way in which our society has an idealised version of the individual is a contrast to Nelson Mandela's views of equality. We can all learn from him. Although Nelson Mandela's voice has been somewhat muffled over the years, the message he put across still rings true to those willing to hear it.

STUDENT
ROSE **SOLTIEL**

DENTS

AIMA and SORAYA ARIF

Everyone

has the right to live out their dreams, even if anything's blocking their way, they should never give up, but should believe in themselves.

PEACEMAKER/AUTHOR/PROFESSOR

Few outside South Africa, expect those involved in apartheid campaigns, knew much about Mandela. Campaigns for his release were spare and invariably linked to others imprisoned. But the technological innovations changing the ways in which we communicate changed all that and the revolutions in the media shrunk our world. The concert at Wembley Stadium celebrating Mandela's 70th birthday televised live across the globe, transformed him from a prisoner without a face into a symbol of resistance to apartheid and all that was evil. He was catapulted into the world of celebrity and the celebrity elites rallied to his cause, and the cause gained traction, momentum and became a galvanizing force of opposition to apartheid.

Freedom for Mandela was a freedom for all of us, cut us loose from the ordinariness of our daily lives and allowed us to become part of something bigger, something noble and unselfish and giving. His release from Victor Vester in February 1992 was televised across the world. A face not seen in 27 years came into focus. Our imaginings collapsed into reality and the reality reinforced our imaginings.

For me two incidents personify the essence of Mandela.

When he had arrived at the conclusion at Pollsmoor prison, perhaps even beforehand, that the armed struggle was going nowhere and that the only way to end the conflict was through negotiations, he wrote to PW Botha requesting a meeting. The letter to Botha did indeed open the path to negotiations, albeit some years later.

Here we see his decisiveness, boldness and willingness to risk his standing within the ANC hierarchy, and even alienate his closest colleagues. Here he exemplified the quintessence of leadership, an understanding that the consequences of his actions might redound to undermine him and his willingness to accept whatever the way the chips fell. But for him, it was the right thing to do and this propensity of his to make decisions that invariably turned out to be the right decisions in whatever circumstances without the express approval of the ANC leadership both elevated him and alienated him. For all of the spirit of comradeship, so prevalent in the ANC, Mandela was and remained an outsider, close to a small coterie who had shared prison time with him since Rivonia.

From his study of Africaans and Afrikaner culture while in prison he knew his enemy, knew the way he thought and instinctively knew what would be required for a peaceful settlement. He told his negotiators to identify White fears and then had them design "a package" that addressed each one and allowed them to agree to the structure of a settlement that was inclusive. Again, Mandela knew that a successful transition to democracy could not be made without the help of those who were part of the apartheid state. Again, his assessment proved to be right and hence the ease of the passage to transition and a democratic South Africa. The white elites were co-opted, the National Party, the party of apartheid, became part of a power sharing government, F.W. de Klerk one of two vice presidents. Not that he could not be tough. At key moments in the negotiating process during his one on one meetings with President de Klerk, he made demands that infuriated the National Party government, put the negotiating process in apparent jeopardy and on every occasion he stared down de Klerk, and de Klerk blinked. Steel. Uncompromising when not to compromise was the "right" course to follow.

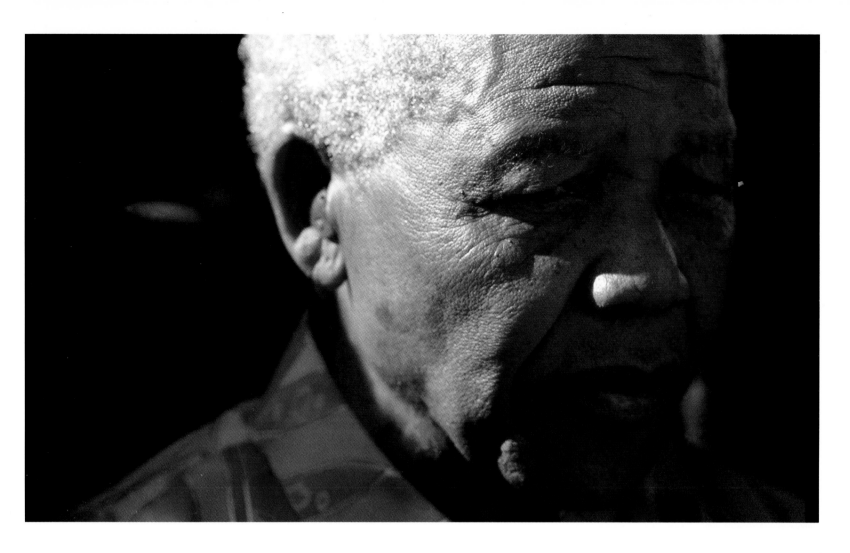

He knew, too, that the a negotiated settlement would only be constructive if it furthered reconciliation, a task he devoted himself to only during Presidency, but as vigorously after he had left office. Lifting South Africa from the quagmire of apartheid, the inculcation of the ethos of a truly representative government was not something that could be achieved overnight or even during one or two presidencies, but a generational task; indeed, one that is still ongoing. Change occurred only when the institutional basis for it was put in place and Mandela, again, laid the foundations of the institutions that would promote reconciliation, equality and reverence for the sanctity of human rights.

Mandela, is an enigma. His persona remained the same — calm, deliberative, detached, observant – a risk-taker whose willingness to forgive those who incarcerated him for twenty-seven years was a genuine act of reconciliation, and gave a moral standing to his years in the presidency and thereafter.

Perhaps we hold him in such high esteem because of the paucity of leadership in the world during the years of his ascendancy when charlatans posed as prime ministers and presidents and advanced their careers at the expense of their people.

Mandela did not seek power, and that which he accrued was used wisely for the benefit of his people. He lived unostentatiously, disposing of the trappings of power, disavowing the aggrandizement and self-seeking that bestrides our political landscape. He is a humble man, but a man not without hubris.

In the end he has lived as a prisoner of his people.

PADRAIG O'MALLEY

SOLICITOR
PAUL CRAMER

A man with no sense of bitterness or malice, **peaceful humble and caring – a truly magnificent human being.**

Nelson Mandela is a man with something I think most of us haven't got. The will and strength of character to overcome and not waver from what he believes in. This man is someone we can all look to for inspiration and positive thinking in our own lives.

BUILDER
LESLIE COMPANY

NICE and KIND.

PAINTER
JOHN COPSEY

EVERYTHING *is* POSSIBLE !

ARCHEOLOGIST
MARIA ANGELES UTRERO AGUDO

ACTOR
DAME JUDI DENCH

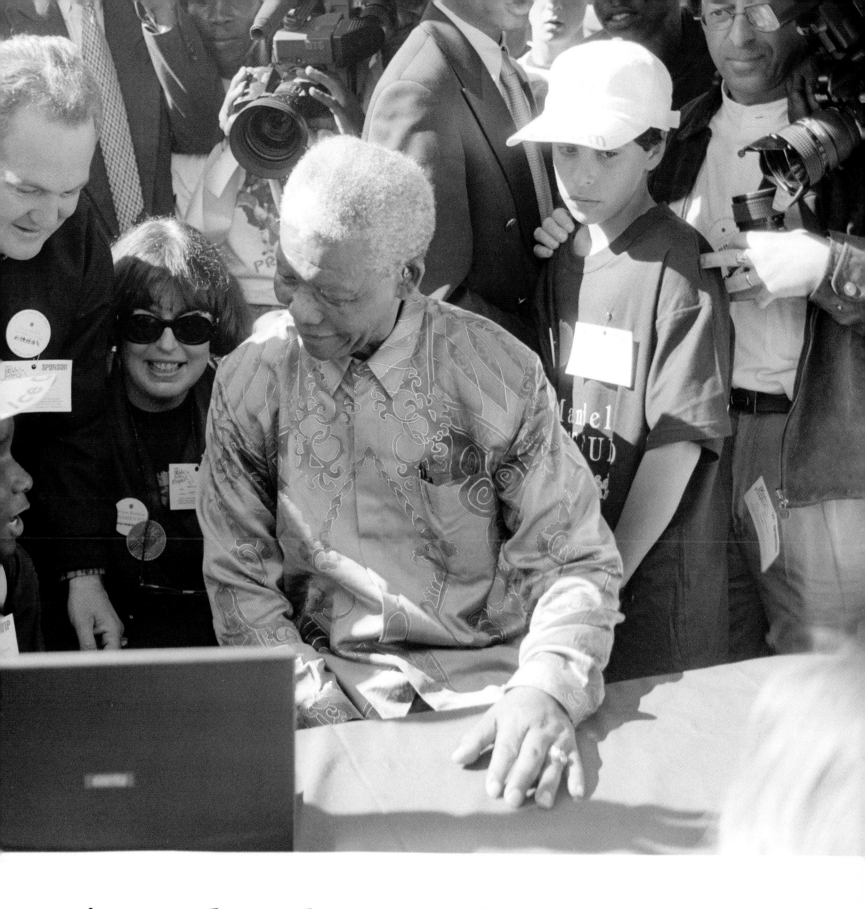

*He's **a modern day Saint**, but I'm sure my quote isn't very original*, **as many people say and think the same thing.**

I guess that for me he is a "personage", a reference about humanity and what somebody can do for others. The message is clear, he is love and respect.

WINE SELLER
INGRID BARE

Uplifting of black people and educating a nation. Footprints in the hearts of many people and an Icon of the struggle of life.

His greatest quality is his ability to touch lives.

POLITICIAN
BRIAN HALEY

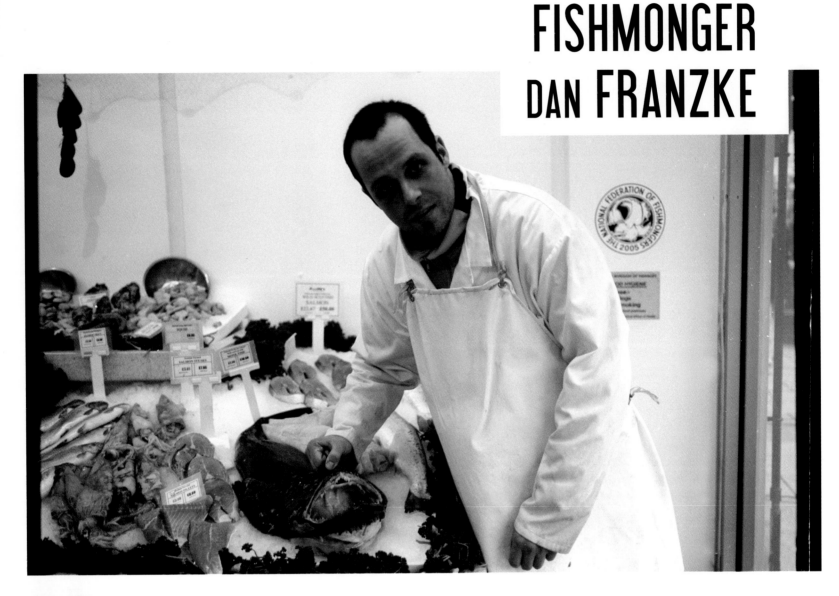

He never gave up.

ELECTRICIAN
MICHAEL CHARLES

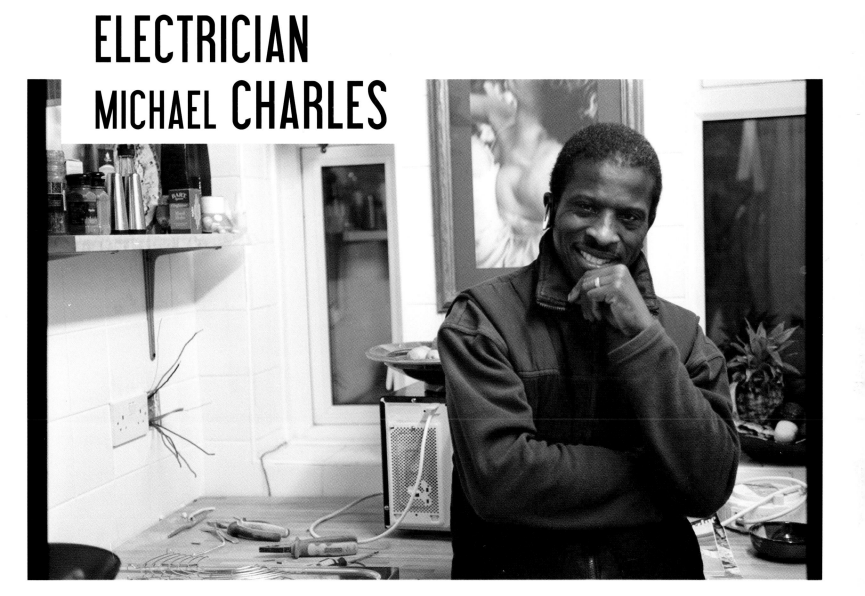

A man of vision.

The greatest vitamins to keep you going in the midst of adverse circumstances – an example of living to pursue a cause, and inspiring others to see they can make a difference, in spite of the odds being against them. Also his attitude of forgiveness towards his adversaries is remarkable, *freeing him from the injustices against him which resulted in his party not carrying out a witchhunt to avenge themselves.*

RETAILER/TAILOR
ALAN RICHARDSON

To see a man who lives this patience, with dignity and humility who is singularly next to God the most loved person on the planet.

SEAMSTRESS
SOHAILA BUTT

He worked hard, he achieved his ambition and was determined to set all black people free.

He is a great man.

He fought for what he thought was right and that was to make all races equal.

COUNCILLOR
DAVID WINSKILL

For a boy growing up in England **in the 1960s and 1970s the struggle against apartheid was an introduction to and an education in politics.** *Most of us felt that when white rule eventually went there would likely be a blood bath.*

Luckily we had Mandela.

He reminded us that even in the most appalling world there can be forgiveness. He made the modern South Africa possible and gave the world a lesson that, sadly, we seem reluctant to learn.

POLICE INSPECTOR
CHRIS PAICE

A man who changed a country to change the world.

ROAD SWEEPER
STEPHEN CUNNINGHAM

He helps a lot of people all over the world and his country which is South Africa.

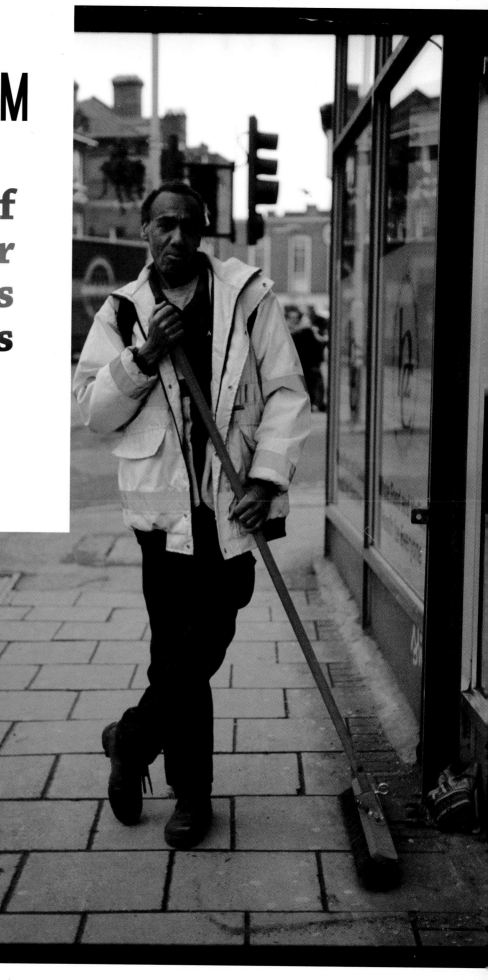

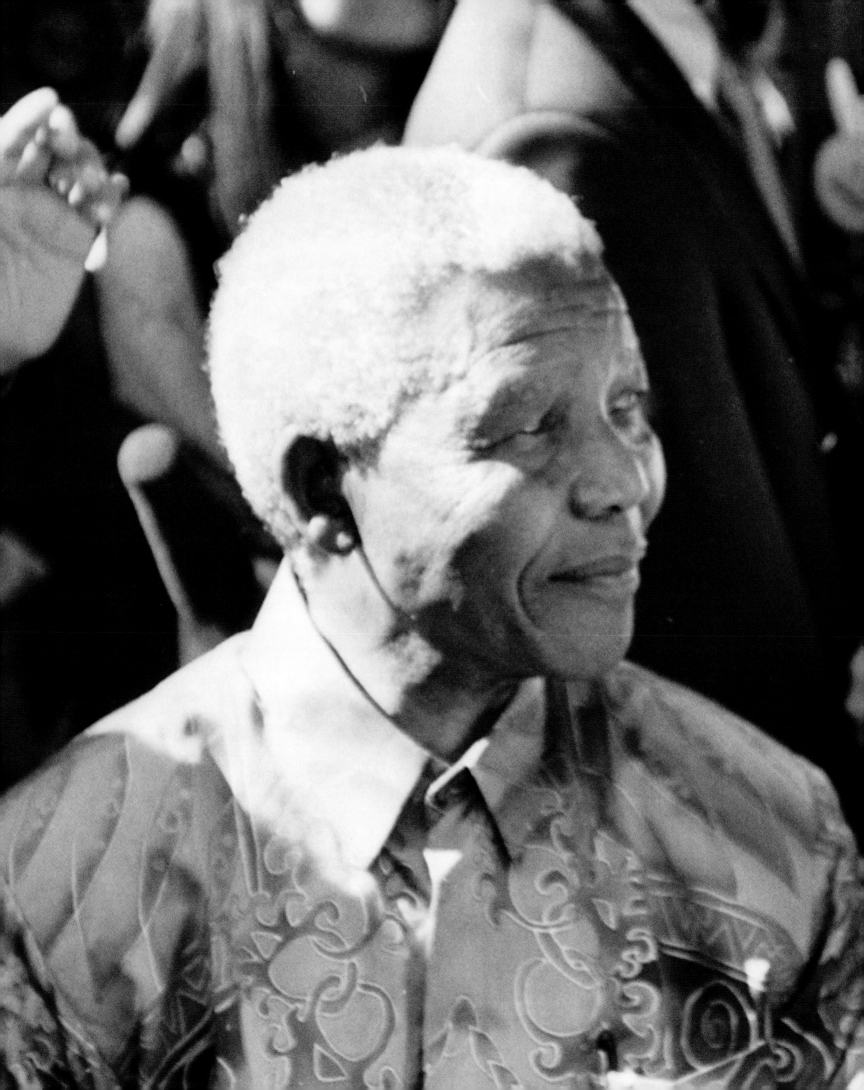

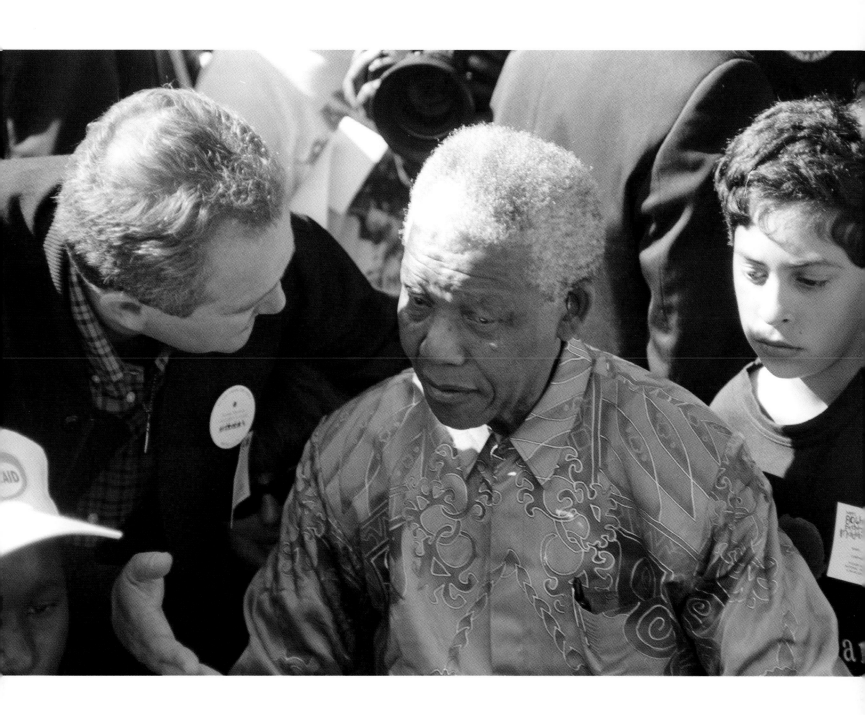

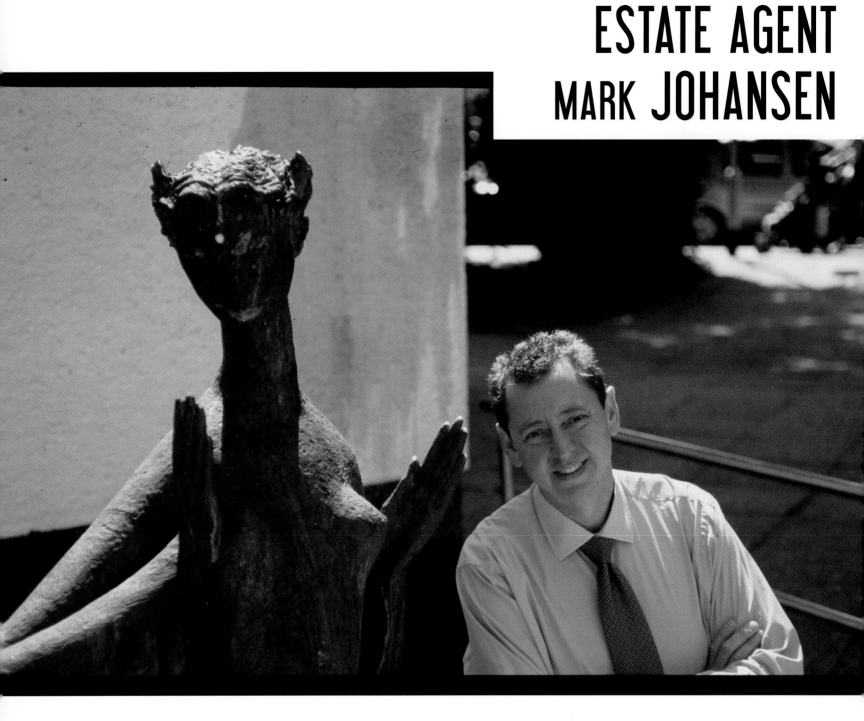

Whenever I need my faith in human nature restored I think of Nelson Mandela.

The cruel injustices he suffered under apartheid symbolise all that is wrong in the world, yet the way he forgave his oppressors is the ultimate example of the good that lives within us all.

STUDENT/ACTOR
TOM KEEPER

We forget how privileged most of us are. *We take for granted the things in life that have the power to change our futures. It is in our developing stages of growing into adults that we can make dramatic influences on how we live.* **Nelson Mandela has always focused on the children as being vital to our existence.**

Without children, humankind ceases to exist. We have inherited from the twentieth century the vision and reality of freedom and democracy. All these very vital rights that we have are the results of the efforts of the ordinary people. *And it is these ordinary people we must urge to be in the forefront in ensuring that every child is given a chance to go to school, of developing human potential,* **because the children will respond to us in accordance with how we nurture them.**

I've often wondered what makes a person great. For me, it's strength and an ability to achieve, that's widely recognized.

In the world of entertainment I have observed many that have reached a high level of achievement making a great impression on me. The rapper Jay Z for instance, taking the art of rapping to the highest level and feeling confident that he can perform before thousands and succeed in captivating his audience.

Where does that confidence come from?

What at first was just a rhyme, becomes lyrics repeated on products sold around the world. When fame and notoriety hits home it must be really scary. Now you are responsible for a great number of people being employed, a great deal of people that will benefit from your art.

I am fascinated by what happens to a person during that transition. I draw a lot of inspiration from that strength of mind and resolve. Many in the entertainment world have found this kind of pressure unbearable.

In his early political years Nelson Mandela must have visualized what his country could be like, thoughts that would drive him to achieving a point in his life where he could speak against the powers that ruled.

People living in democratic non-violent lands during election times, need to appreciate what it takes to challenge laws that advocate separating people by colour. The young Mandela would have felt he could change things, where so many before him had failed.

Nelson Mandela was an ideal target for political success.

His jailing reflected the fear of his leadership from the then government in South Africa. He stood up to oppose apartheid and paid the price with incarceration like many others before him. On his release from prison the platform given to Nelson Mandela was mighty. The way Mandela handled this new calling in his life is what makes admiring him so easy. From a confined position in his life that would have challenged the sanity of most individuals, Nelson has shown tremendous compassion and control giving the political party The ANC, a leader that would recover South Africa's political standing, pulling it in line with the rest of the world.

Nelson Mandela's confidence (at work) as president of ANC must be admired around the world. In my comparison with an entertainer I believe only a select few in the world of fame and celebrity change things on a massive scale. With the entertainment comparison, I look at the two characters and their mental ability to handle success in different areas.

For Mr Mandela his transformation from a political prisoner to a nation's leader is an unparalleled change. This has motivated me to believe that I can achieve in areas outside my expectation.

I'm aware that achievements always come with a price attached. Some heavy, some not so...

It just depends on how much you are prepared to pay...

COURIER
KEVIN PINNOCK

MANAGING DIRECTOR
DIANNE STRAUSS

I remember all those years and all those articles that endured while Nelson Mandela spent what was our lifetime in jail, and I wondered how he continued to smile, or in fact survive. What I learned from Mandela is patience. Everyone has their day.

An **unshakeable** **h u m a n** being. He's **stayed** true to himself and his beliefs which should be so simple and has inspired genera-tions by being a good and strong human being.

P.R/MARKETING
JESSICA LUCY COATES

He taught us the most powerful weapon for good is the ability to forgive.

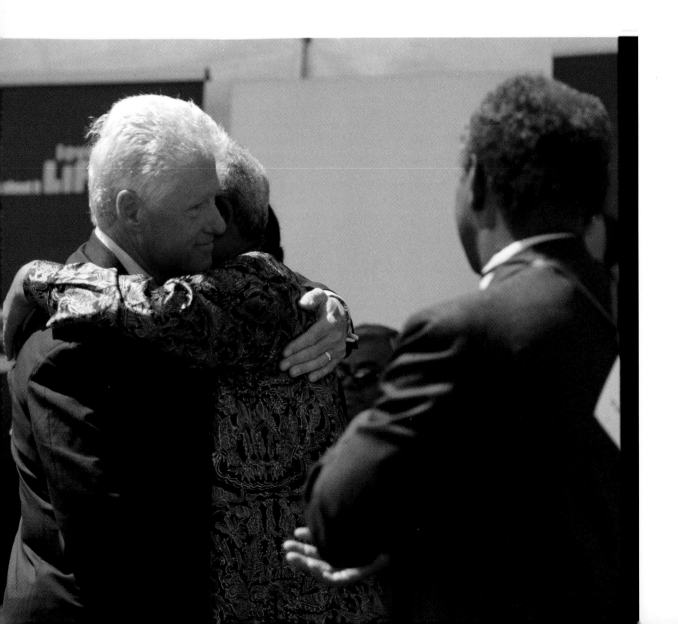

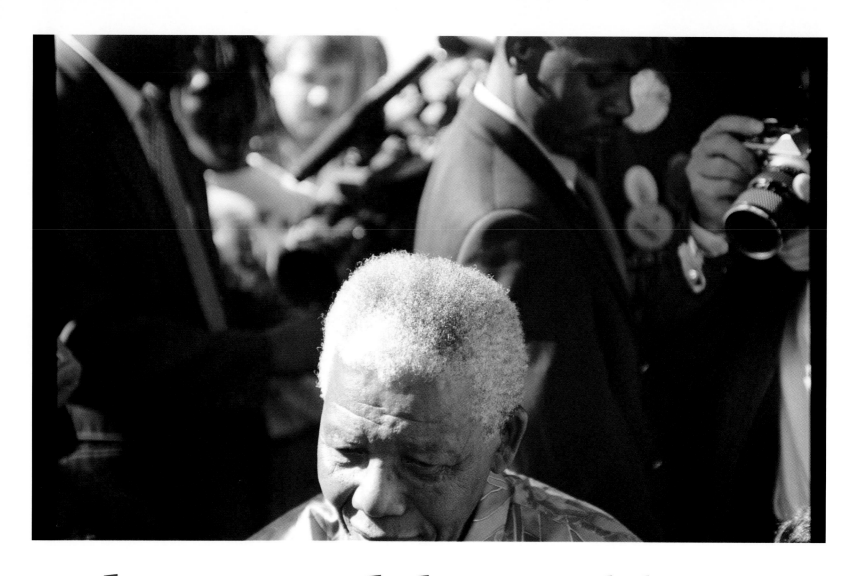

Nelson Mandela, Madiba, the man I am privileged enough to be able to call 'grandfather', is one of a few great individuals who have profoundly affected all mankind and help change the world we live in.

MODEL
NAOMI CAMPBELL

He has inspired me personally in so many ways, **I am blessed to have had the opportunity to spend time with him and learn from his great wisdom.**

He taught me to always have an opinion, not to be afraid to speak my mind and that we must not be held back by fear. Those personal lessons are ones he has also taught the world. He has shown us all that no matter the difficulties and struggles that may be in your way you should always stand up and be heard, **we should all stand up for what is right.**

27 years in captivity could not break his spirit. *If he could live through oppression, the denial of his freedom and separation from those he loves, yet still greet his captors in the spirit of forgiveness and reconciliation then there is nothing that we as a people cannot overcome together.*

His greatest lesson to the world, to mankind, is to love each other, and to forgive. *He has shown, through his virtue, that we must look past the things that separate us and make us different and embrace that which we have in common.*

Rich, poor, black, white, young, old, we are all in this together, we are one society.

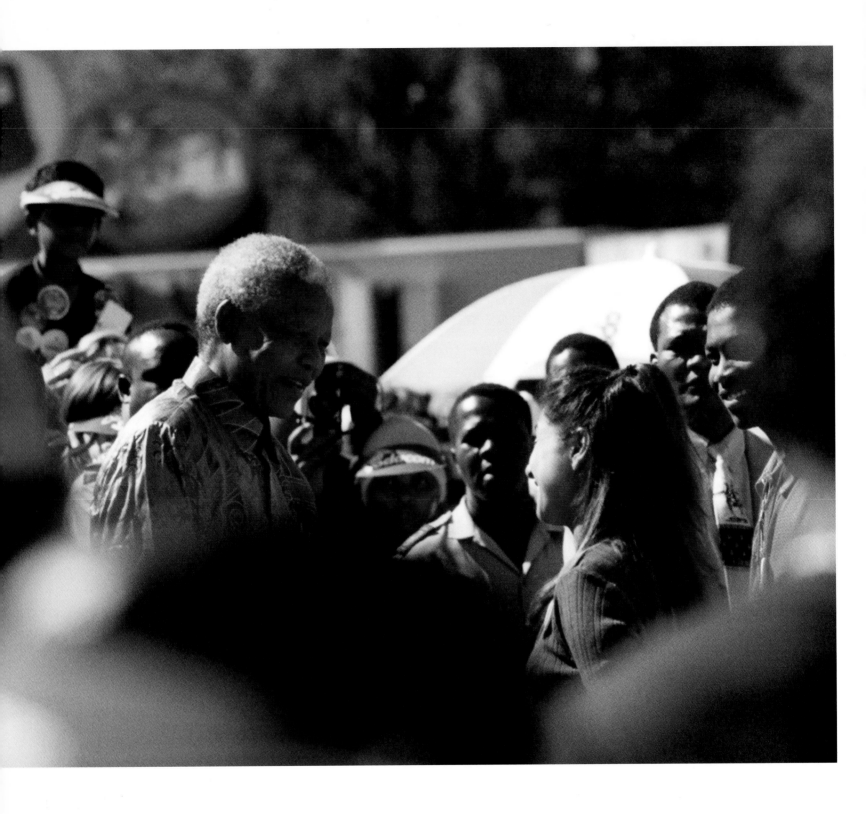

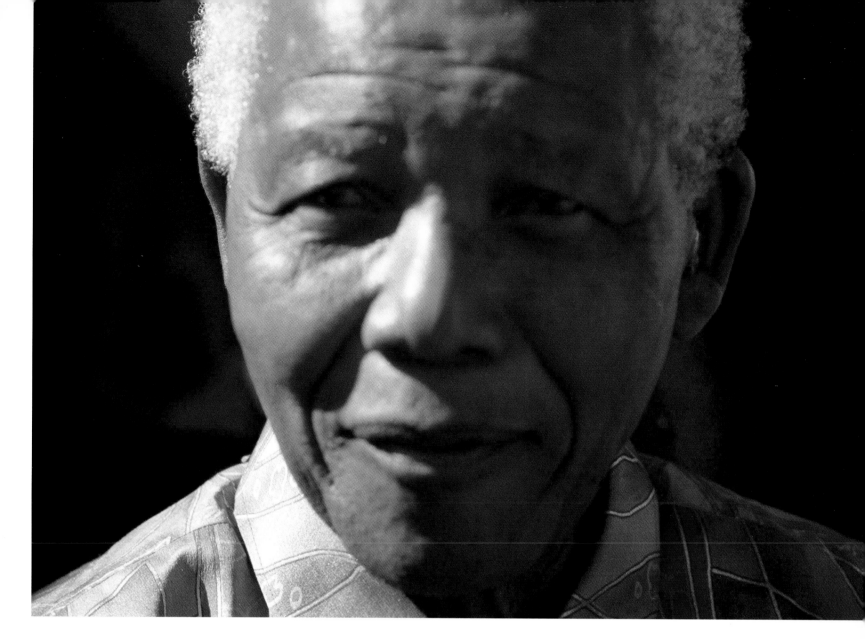

"I think there are few individuals in our world like Nelson Mandela that embody the values of **forgiveness, perseverance, compassion and personal sacrifice.** Through leading by example, he has taught us many lessons. Among them, and most relevant to our society today, is the belief that **although progress takes time, it is possible.**"

SINGER
BARBARA STREISAND

I think we need to be cautious when we speak of Nelson Mandela. There is a tendency toward idolatry in popular perceptions of him. *That is, there exists a lack of critical analysis of hidden words and activities.* I see a great danger here: as soon as someone is idolized that person ceases to be the subject of scrutiny and all they say or do is taken at face value.

This trend is evident even in the proposed title of this work: "Mandela: Icon of Peace".

This is not to say that Mandela is deserving of unsubstantiated criticism. On the contrary – I believe him to be an admirable figure who is effective in reaching into the public conscience to give substance to and affirm ideas of justice, accountability, action and peace. He makes the intangible tangible. He gives life and breath to concepts most of us can deal with only theoretically. *I thus argue that it is in* the interest of strengthening Mandela's positive attributes *to open up critical and analytical debates about his ideas and actions in order to move away from sociological and political 'thin ice' resulting in perpetual idolatry.*

STUDENT/COUNTY DIRECTOR
THE AFGHAN CENTRE
JENNIFER McCARTHY

Mandela. The name is synonymous with courage and perseverance.

Every true leader has these qualities, but there are very few genuine leaders.

Having just finished a documentary on the life of Benazir Bhutto, the slain prime minister of Pakistan, I cannot help but see parallels between them. They both fought for their convictions in the face of tyranny and extreme danger. **Prison walls could not dampen their devotion for democracy and equality.**

Threats and intimidation only solidified their cause.

The world should take heed of such dutiful humans. Mandela is a testament to the triumph of spirit and the best of all our natures.

DIRECTOR/EDITOR BHUTTO
JESSICA HERNÁNDEZ

DOCUMENTARY/PHOTOGRAPHER
MATHEW WILLMAN

Mandela

teaches us to believe in something that is much bigger than ourselves. *It is this belief that gives us the strength to stand alone. Mandela is an example to us all of what it means to have an unmovable belief and principle on something unseen with vision and resolute determination.* **It is taking that which is good in each of us, eliminating the negative and accentuating the positive.**

AIRLINE PILOT/SAXOPHONIST
ANDREW GODWIN

Nelson

Mandela's life is a constant reminder of the ugly and painful price we pay and indeed continue to pay in the defence of truth and liberty for all particularly in our continued struggle against racial tyranny and oppression in its multi-raced disguise today. The struggle continues.

PRESIDENT CHARTERED INSTITUTE OF JOURNALISTS
SANGITA SHAH

The symbol of humility, warmth and compassion. Mandela personifies the greatness that is part of us all - *and reminds us of what we can be if only* **we unshackled ourselves from our mundane lives** *and sought to recast ourselves within the context* of **the challenges facing** *our world today.* **His greatness comes in his humanity and it is this that I see in my two year old son today** – *and so desperately yearn to know how to retain such* **untainted determined optimism.**

MP
LYNNE FEATHERSTONE

Mandela, having fallen prey to the temptation of violence, found another way to make the **world better.**

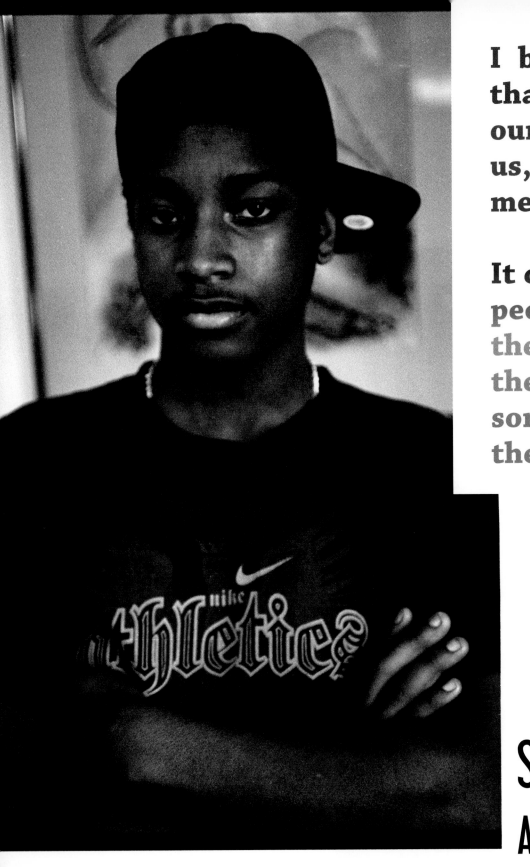

I believe it teaches us that we should not let our hardships weaken us, but make us stronger mentally.

It can also teach us that people can change for the better if treated in the right way, although sometimes this is not the best strategy.

STUDENT
AARON BRADFORD

The right for everyone to be equal and the right for different races to mix equally. And the right for every race to be seen the same. His frame of mind, the way he sees every race equally.

STUDENT

MITCHELL PECK

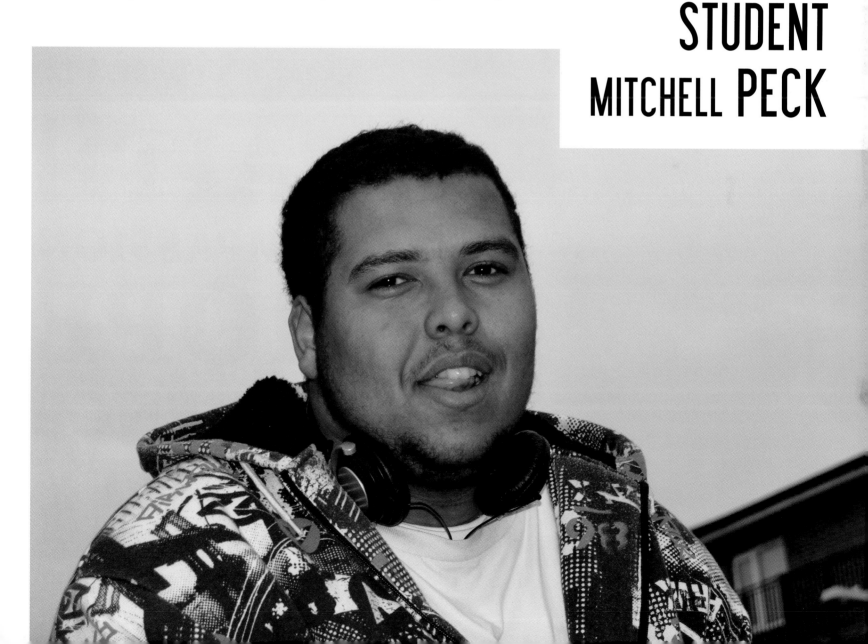

STUDENT
PAULA HIGGINS

You changed the world Mr Mandela. For my father Vincent Higgins 1926-2002, we rejoiced together on the day of your release. The other great man in my life.

FAITH
COMPASSION
HOPE
PATIENCE
DIGNITY

SOUTH AFRICAN CULTURAL ATTACHÉ
MABETT VAN RENSBURG

That ordinary people can achieve miracles and great things.

EXECUTIVE DIRECTOR
NELSON MANDELA CHILDREN'S FUND UK
KATHI SCOTT

Mr Mandela's example teaches us the importance of **SHARING**. *He is an extraordinary man, a world icon, a symbol – but he is also a man who has strengths and weaknesses and someone who never works as a lone agent.* **He teaches us that with help from other people, you can make your mark on the world.** *That instead of always competing for power, we should give a voice to lesser known individuals, and be at ease with Kings and the common man.*

He drives us on to fight the increasing challenges that our societies are facing today *and that all problems are valid. And he has taught us that Happy Endings are possible.*

I have learnt from Mr Mandela that we are all meant to shine *and by hiding away you can't serve the world.* **I have learnt that personal sacrifice, being selfless and dedication is far more powerful than simply telling people you want to make a difference.** **That simplicity,** *a hug and taking the time to* **notice the colour of a person's eyes are important. And always to smile and say** **Thank You.**

"Nelson Mandela is the **GRAND,** **courageous** *and* **visionary** LEADER *of the late 20th Century!"*

PROFESSOR

164. CORNEL WEST

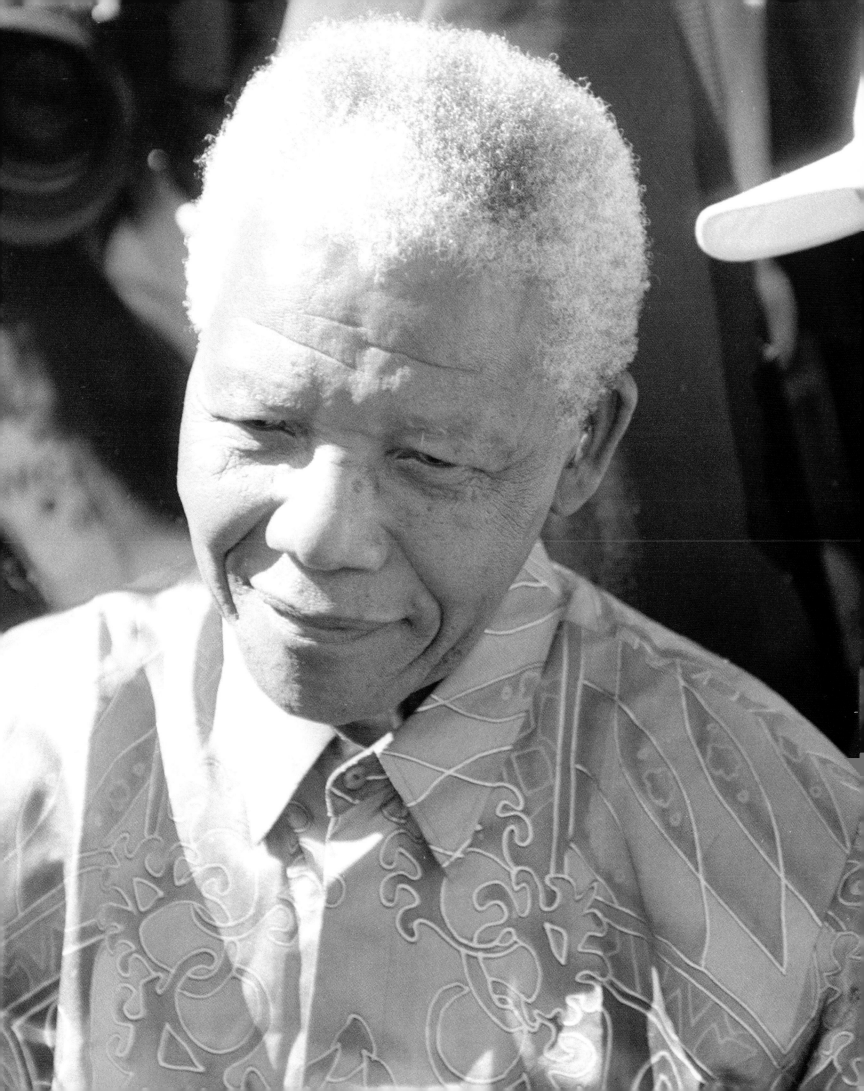

GOVERNMENT SPECIAL ENVOY FOR YOUTH CRIME
RICHARD TAYLOR

Nelson Mandela believed that the apartheid regime denigrated the black race and he fought to liberate the blacks of South Africa from the white pharaohs of the establishment. He paid the price by losing his best manhood years in prison but he defeated apartheid and drove the process to transform South Africa to the society of his dream.

At the time Nelson Mandela was fighting **apartheid, it was the worst evil to visit black mankind.** *When he came out of prison,* **HIV/AIDS was decimating the productive population of South Africa. AIDS struck home and snatched his son. He led the fight against HIV/AIDS with the same passion and compassion for humanity, championing the cause for the control and prevention of this present evil.**

In a continent known for despotism, corruption and visionless leadership, **Mandela led South Africa without provoking governance misdeeds.** *He did not linger a day in office longer than his tenure.*

This one man has delivered the promise that messiahs are indeed born in the continent of Africa, **the question would be which leader is willing to serve with compassion, denying the self.** *For it is in the arena of altruism, serving the good of the people and denying the self that African leaders stumble and fall.*

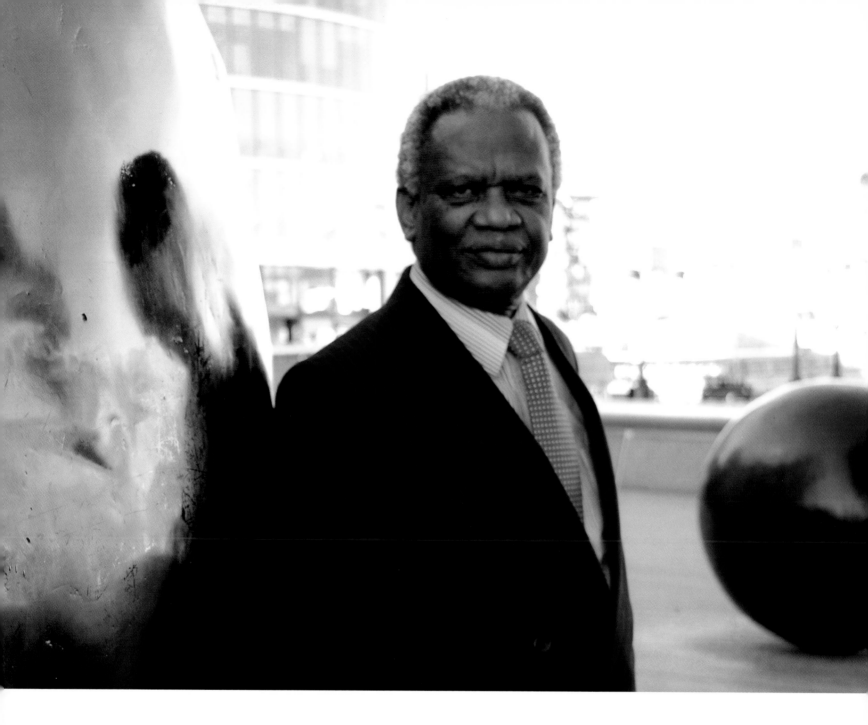

There are bevies of beautiful women, mountains of gold and the decadent pleasures of the idle rich which are for having in the corridors of power of impoverished African States. After all, misdeeds which erode public morality can be excused by incoherent admissions of devotion to traditionalism. **When will the visioning take place, for the ideas that will transform Africa are forged on the crucibles of pain, at the human suffering, disease and poverty in Africa and the arousal of a fierce spirit to liberate the people.** *It starts with denuding oneself of all but essentials for a dignified existence.* **Ask Ghandi, ask Mandela.**

Unless African leaders are cast in like mould as Mandela, the journey to development will never reach a destination.

MEMBER BSC,
DIRECTOR FILM PHOTOGRAPHY
PETER BIZIOU

Modern mankind can learn to continue the amazing recent progress made by Nelson Mandela with his unselfish commitment and contribution to our evolution.

He said "Never, never and never again shall it be that this beautiful land will again experience the oppression of one by another"

I take this to mean, **a true sense of equality amongst human kind, whatever colour or creed. We are all kindred.**

Mandela is giving his whole life to his belief, **surely, we can all give a little more of ourselves and slowly very slowly as in evolution, we may develop and improve the collective consciousness.**

On this we must teach our children.

He *is* **utterly selfless, altruistic** *and* **magnanimous**

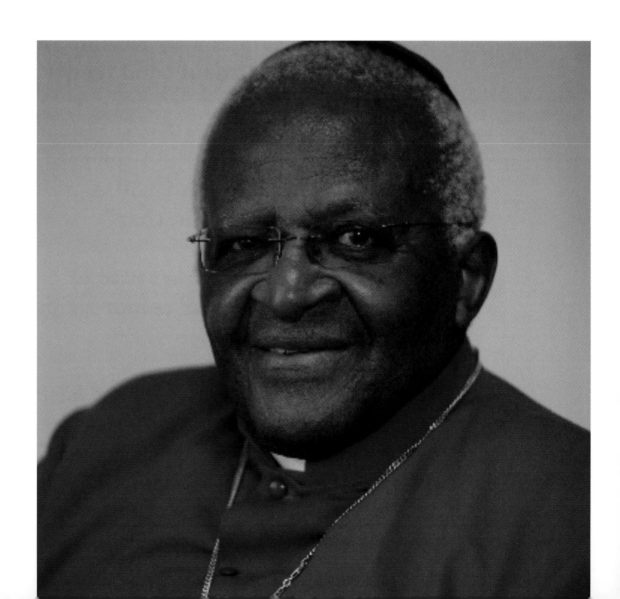

Nelson Mandela is **a beacon of hope** *and* **peace.** *He has done wonderful work* **helping to reconcile diverse communities in South Africa.** *His values and virtues tell us that we should never give up.* **Love your enemy, embrace your opponents and dare to dream.**

RIGHT ARCHBISHOP OF YORK
JOHN SENTAMU

SECURITY
ADE AFILAKU

Everyone can be together, all different colours on the outside but all red on the inside.

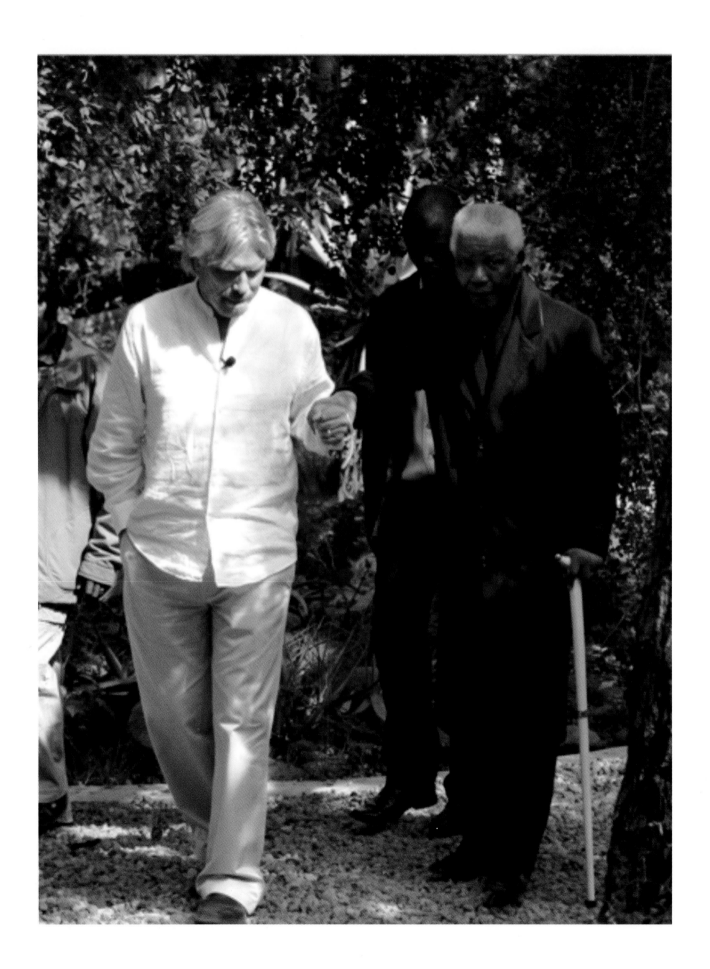

Forgiveness.

If everyone in the world befriended the person they've most fallen out with, they – and the world – would be a much happier place.

BUSINESSMAN
SIR RICHARD BRANSON

A *special* THANK YOU *to:*

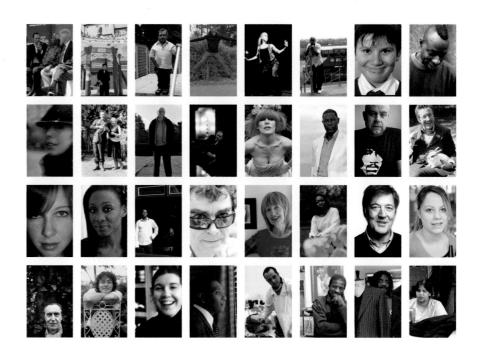

Mr Nelson Mandela

Kathi Scott, Nelson Mandela Children's Fund, who encouraged me, believed in the project, and has become a wonderful friend.

Titan Books, Laura Price, Rodolfo Muraguchi.
Proud Galleries
Marilou Rabourdin for a fantastic design and patience.

Sir Richard Branson, with thanks also for his photo.
Anthony Osmond-Evans, Sydney Duval, Alf Kumalo, Terry Mansfield

The Society of Authors

My son, Nikolas Balfe
My husband, Paul Morgan
My Mum, Lili, my Dad, Rudolf, and step-mum Eva,
my parents-in-law Betty and Laurie
My sisters, Caroline Olds, Julia Haselhorst,
sister-in-law Dinah Sherriff. My brother, Moritz Haselhorst.
My cousins, Phillip Haselhorst and Victoria von Uckerman,
Victor Haselhorst and Martina. My niece and nephew Candice
Olds-Tserliangos and Alexander Gabriel Gabison, Scarlett and
Zeff, my aunts and uncles.

Judi Gasser, Tania Thompsen Poole, Clea Brislan, Tim Mahoney, Rachael Ward NMCF, Simon Morgan for his journalistic help, Kasia Morawski-Wendt, Gill Hudson, Michelle Callaghan, Richard Reynolds, Alex Proud, Kate Boenigk.

Photo of Archbisop Desmond Tutu, By Benny Gool
Thank you to The Mayor of London office for photo of Boris Johnson. Photo of Stephen Fry, by Claire Newman Williams.

Dennis Haysbert photo: Victoria Jackson, makeup stylist; Sharon Globerson, clothing Styling; Geevani Singh, Management; Michael Parker, Hair – ABetterCutServices.com

Foto Plus, 3 Park Road, Crouch End, London, N8 8TE

Rose Templeman, Hamish Jenkins, Gemma Waters, Debora Cunhar, Sarah Aldridge, Lucy Baxter, Tatyana Levy, Teresa Rudge, Dina Azzam, Robert Norman, Rob Prinz, Ashley Robinson, Adam Isaacs, Helena Fills, Lili Pollock, Rupa Balasubramanian, Tracy Quinn, Martin Erlichman, Wendy Singer, Denise Martin.

Apple computers.

To all the people for helping believing in me, since the beginning of my journey and in:
Reflections on Nelson Mandela: Icon of Peace

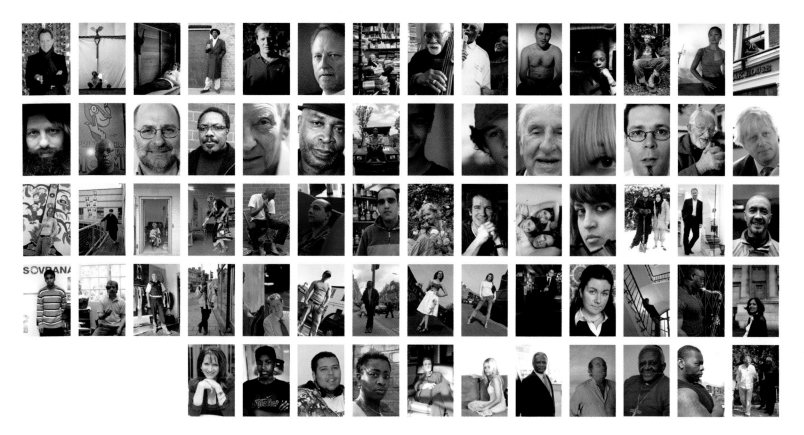

KEVIN SPACEY	STUART ROUND	SILKE BARTELS	CHRIS PAICE
ARNOLD SCHWARZENEGGER	JAY TURNBULL	ZOË HAWKINS	STEPHEN CUNNINGHAM
FUN TONG	DENNIS HAYSBERT	SHEENA MCDONALD	MARK JOHANSEN
SIMON MINTY	CLIFF PARISI	T.N.NDEBLE	TOM KEEPER
PETER CAMPBELL	ROLAND RIVRON	SARAH NAGAR	KEVIN PINNOCK
ELLIE GLIKSTEN	AARON BARSCHAK	MUYO NDEBLE	DIANNE STRAUSS
TREVOR NELSON	HORACE ARCHER	SOLOMON SALIM	JESSICA LUCY COATES
MAX BEDFORD	ARNIE UNISEN	GHAZAN NAWAZ	ALEX PROUD
MARCUS HAMILTON	RANDHI MCWILLIAMS	ANNA NYGH	NAOMI CAMPBELL
RICHARD E GRANT	WHOOPI GOLDBERG	STEVE HOLLOWAY	BARBARA STREISAND
STEVE BAYLOCK	RICHARD LINDLEY	ZARA, MILA, CLEA BRISLIN	JENNIFER MCCARTHY
ADRIAN DUNBAR	HENSON ROUSE	SARAH NAGAR	JESSICA HERNÁNDEZ
JUDE BAPTISTE	PETER MOUTLOATSE	ROSE SOLTIEL	MATHEW WILLMAN
ALISTAIR CAMPBELL	SHERRIDAN GRAHAM	NORAIMA AND SORAYA ARIF	ANDREW GODWIN
JERRY LEES	NIKOLAS BALFE	PADRAIG O'MALLEY	SANGITA SHAH:
A.C GRAYLING	JOHN MILLS	PAUL CRAMER	LYNNE FEATHERSTONE
COLERIDGE GOODE	SOPHIE O'NEILL	LESLIE COMPANY	AARON BRADFORD
DIANA ROSS	RONAN PRIMO	JOHN COPSEY	MITCHELL PECK
JOHN WRIGHT	SOL SAUL	MARIA ANGELES UTRERO AGUDO	PAULA HIGGINS
SAMMY WILSON	BORIS JOHNSON	DAME JUDI DENCH	MABETT VAN RENSBURG
FRANCIS HEALY TRAVIS	JADE POOLE	INGRID BARE	KATHI SCOTT
SU-MAN HSU	BEVERLEY KNIGHT	BRIAN HALEY	CORNEL WEST
CARLOS SAINT BEAN	KEITH CLAYTON	DAN FRANZKE	RICHARD TAYLOR
KATE MOSS	JOHN TURNBULL	MICHAEL CHARLES	PETER BIZIOU
DELPHINE PREAU	CAROLE STONE	ALAN RICHARDSON	ARCHBISHOP DESMOND TUTU
MONICA RIVRON	AVIS GHARLES	SOHAILA BUTT	RIGHT ARCHBISOP OF YORK JOHN SENTAMU
SIR MICHAEL PARKINSON	STEPHEN FRY	MEHLOAB AHIMED	ADE AFILAKU
CELINE DION	ARPAD BUSSON	DAVID WINSKILL	SIR RICHARD BRANSON